# LEONARD
# McCOMB

Organised by the Museum of Modern Art Oxford
and the Arts Council of Great Britain

# Leonard McComb

## Drawings Paintings Sculpture

Serpentine Gallery London
October 17th November 20th 1983

Museum Of Modern Art Oxford
November 27th January 15th 1984

Manchester City Art Gallery
January 24th March 3rd 1984

Gardner Art Centre University Of
Sussex March 14th April 12th 1984

Fruit Market Gallery Edinburgh
May 26th June 23rd 1984

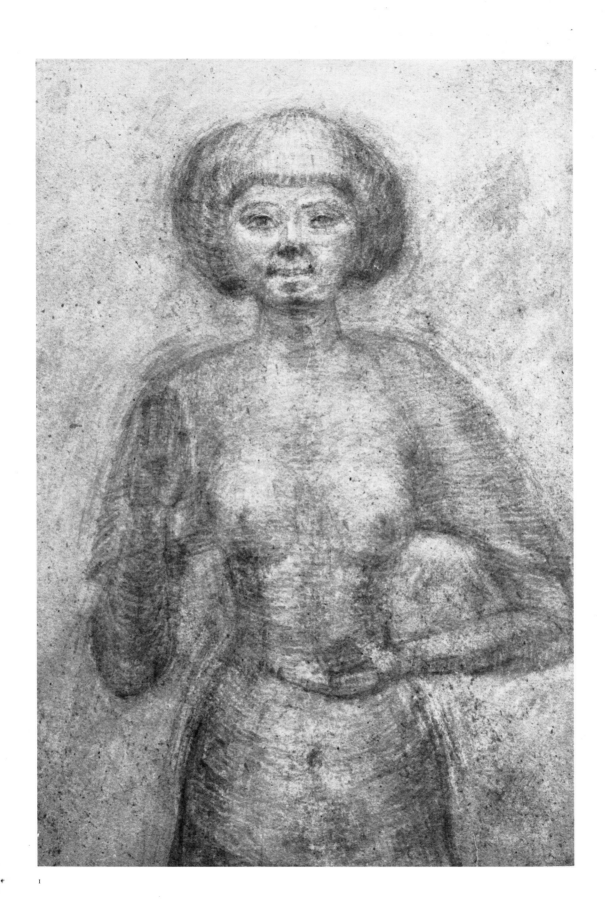

I

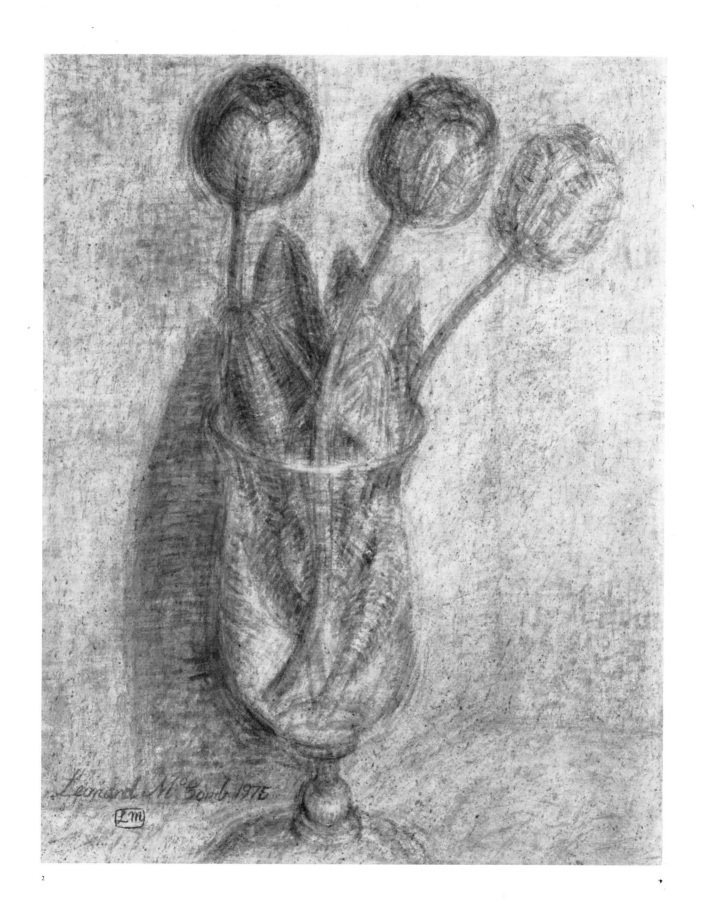

Leonard M<sup>c</sup>Comb 1975

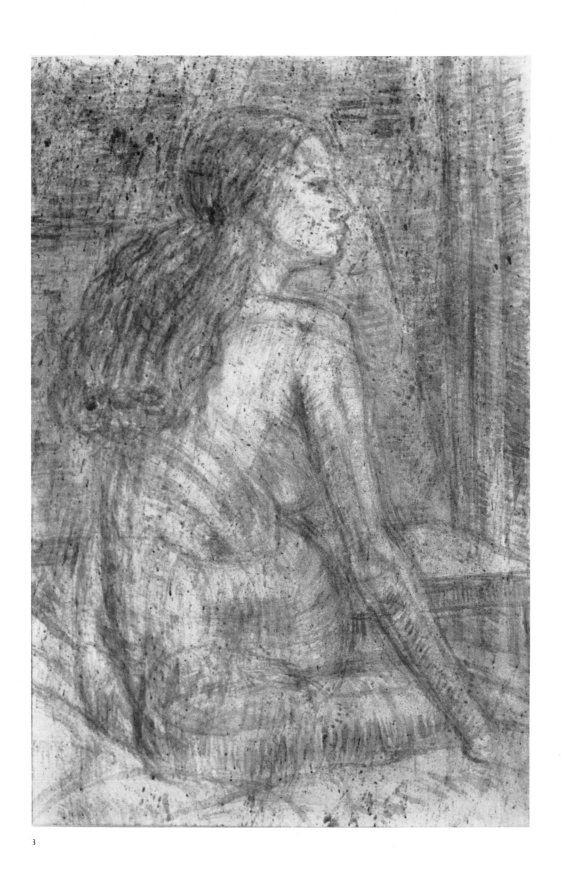

3

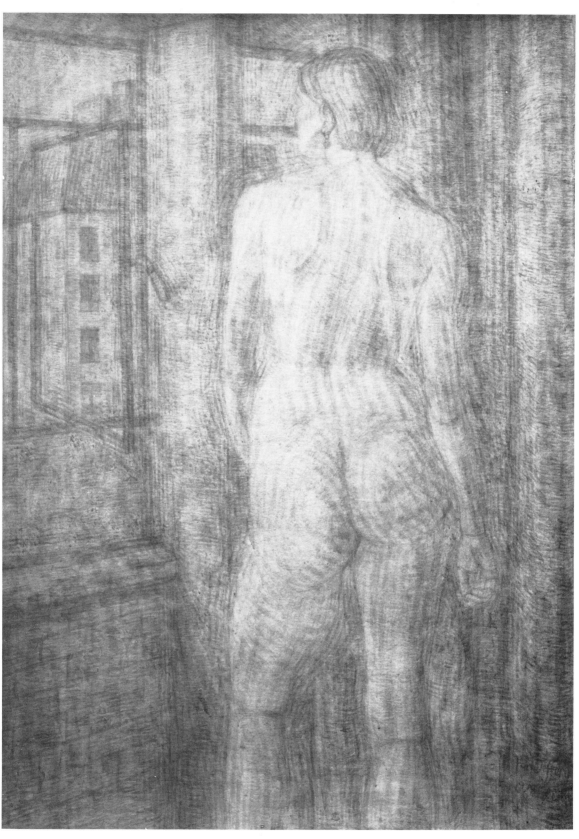

40

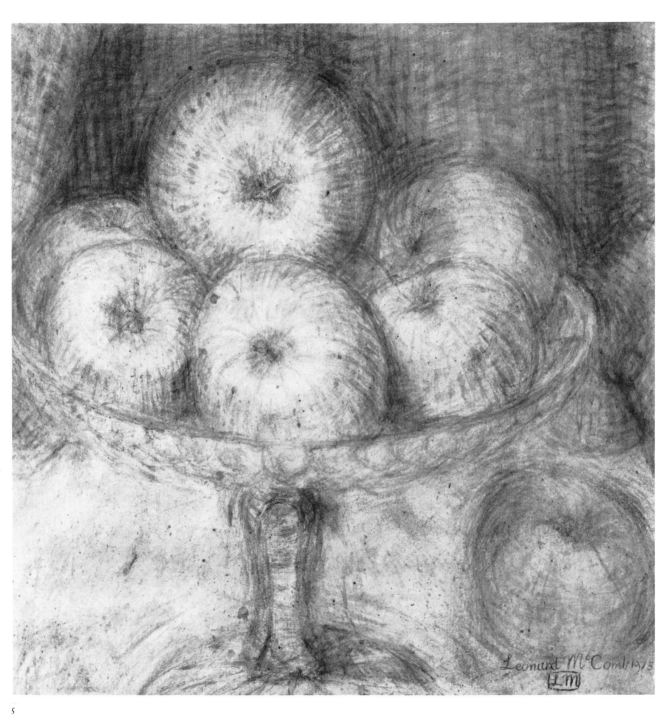

5

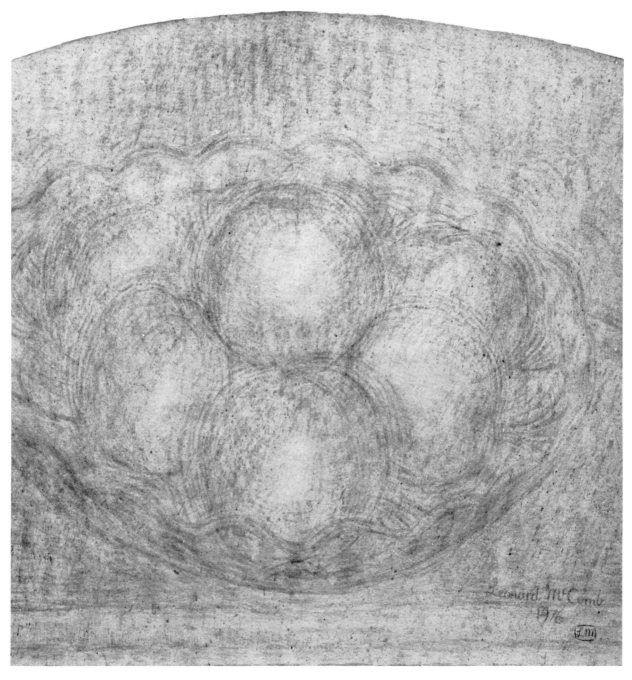

23

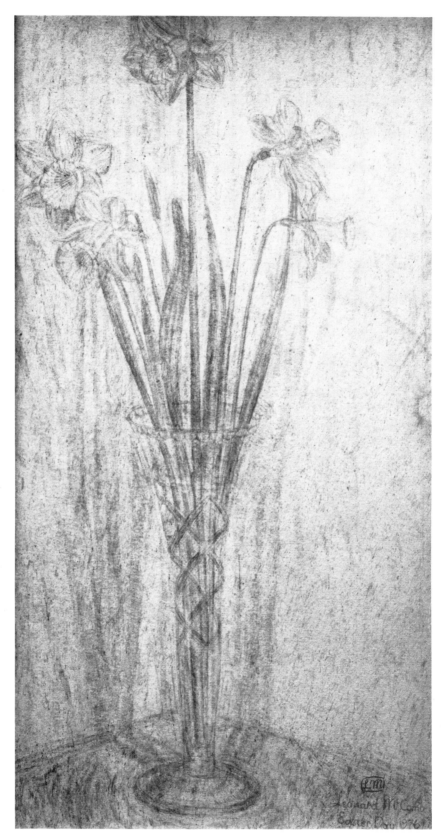

24

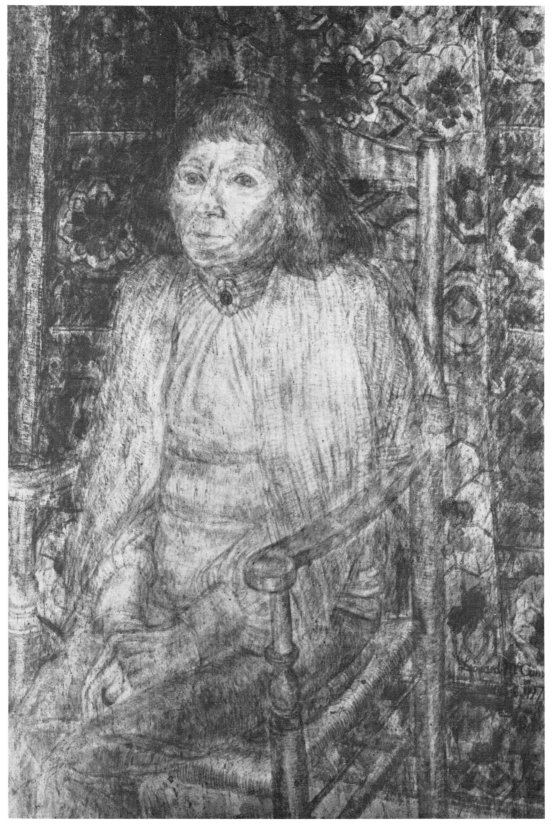

25

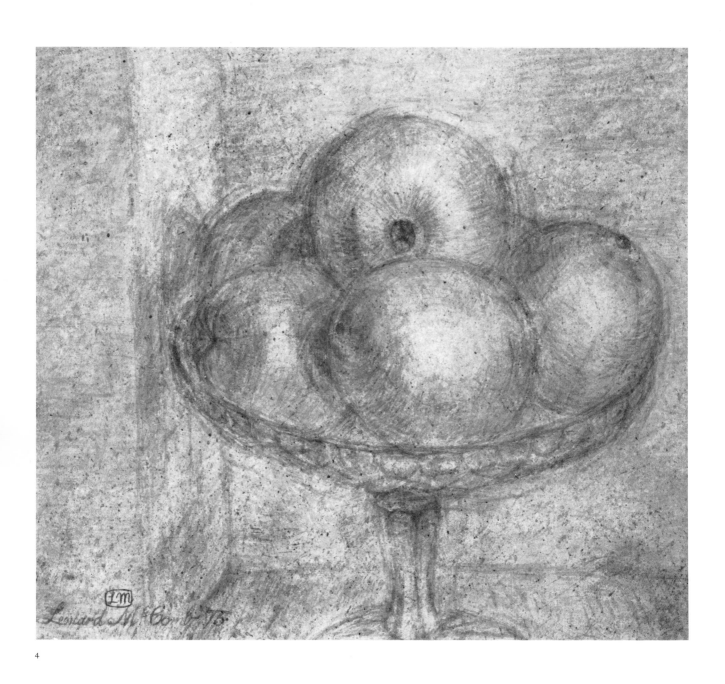

4

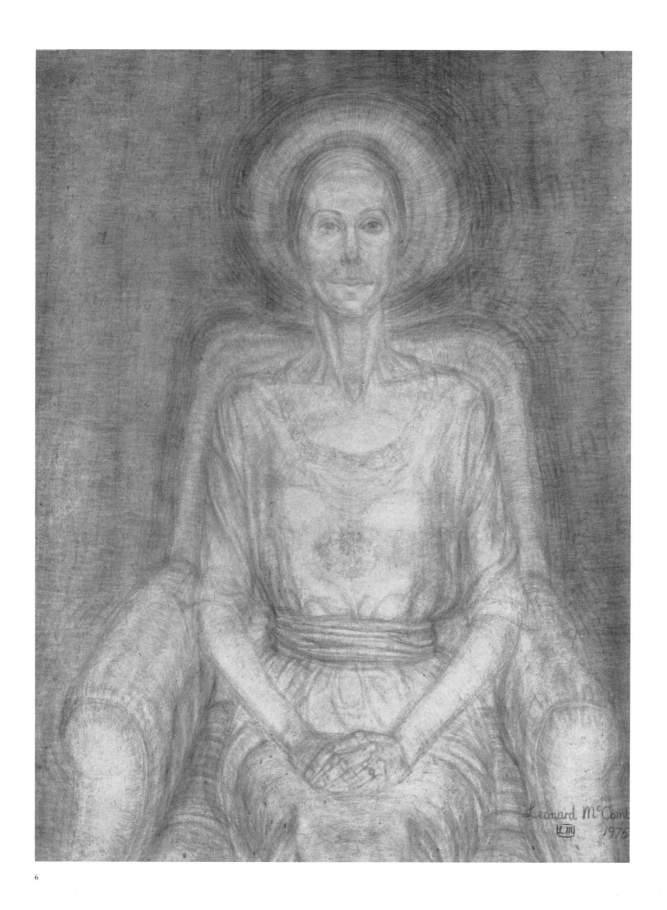

6

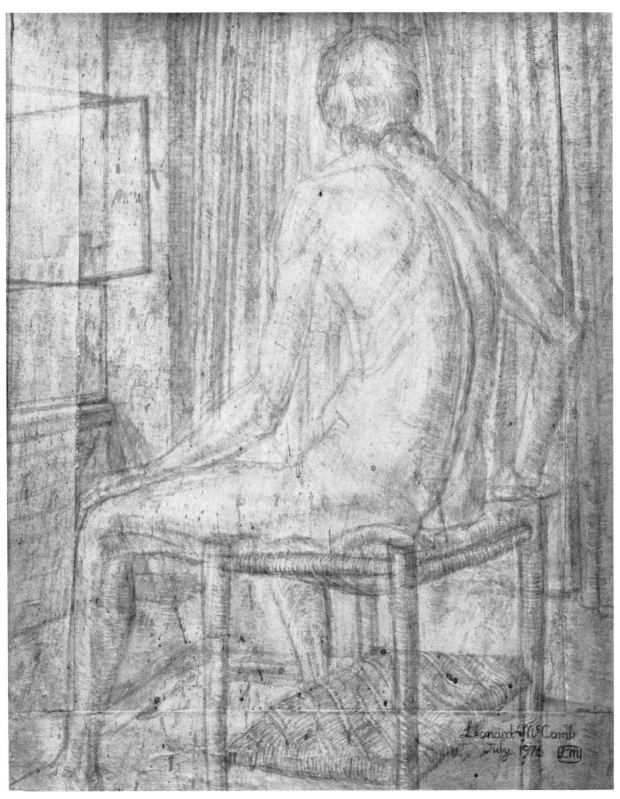

18

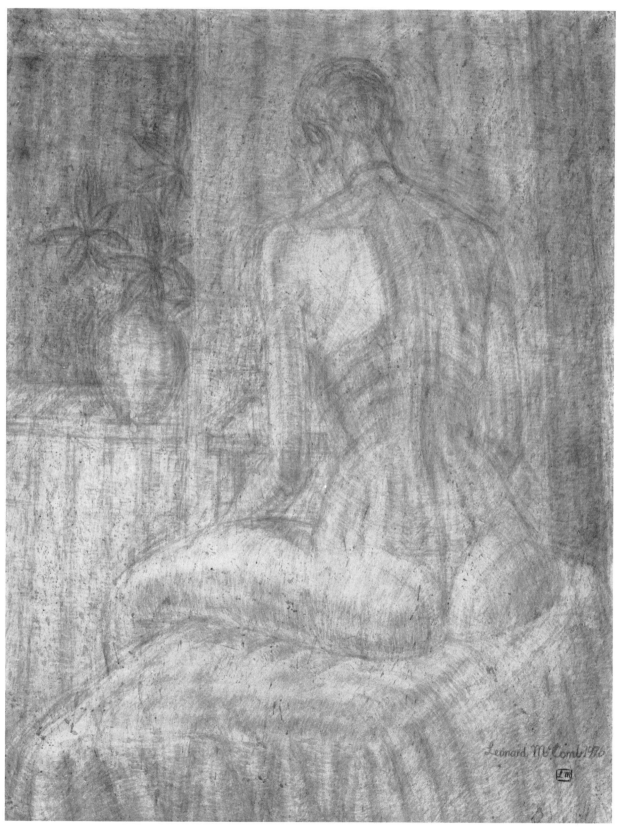

13

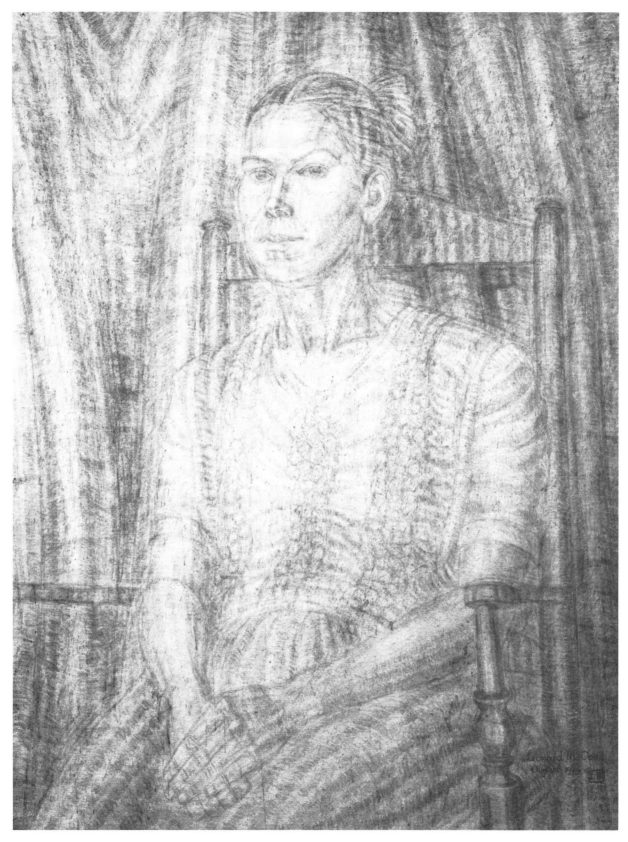

16

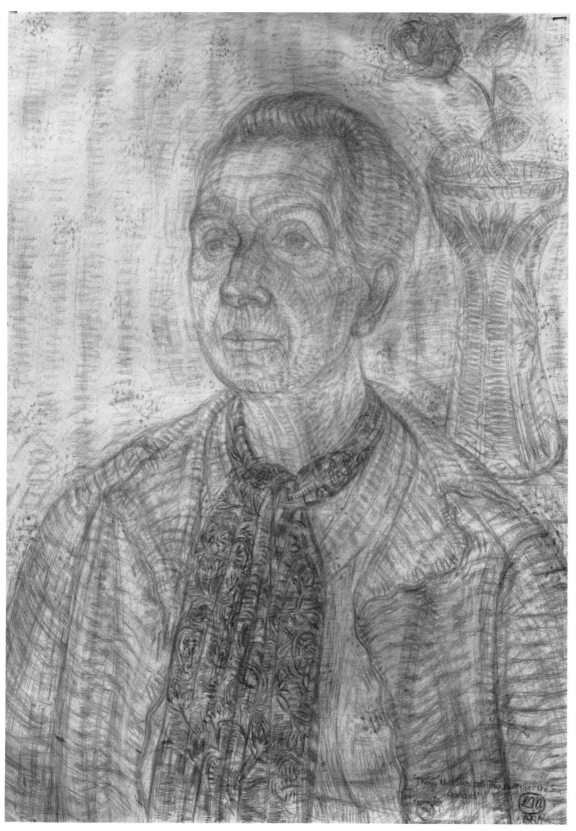

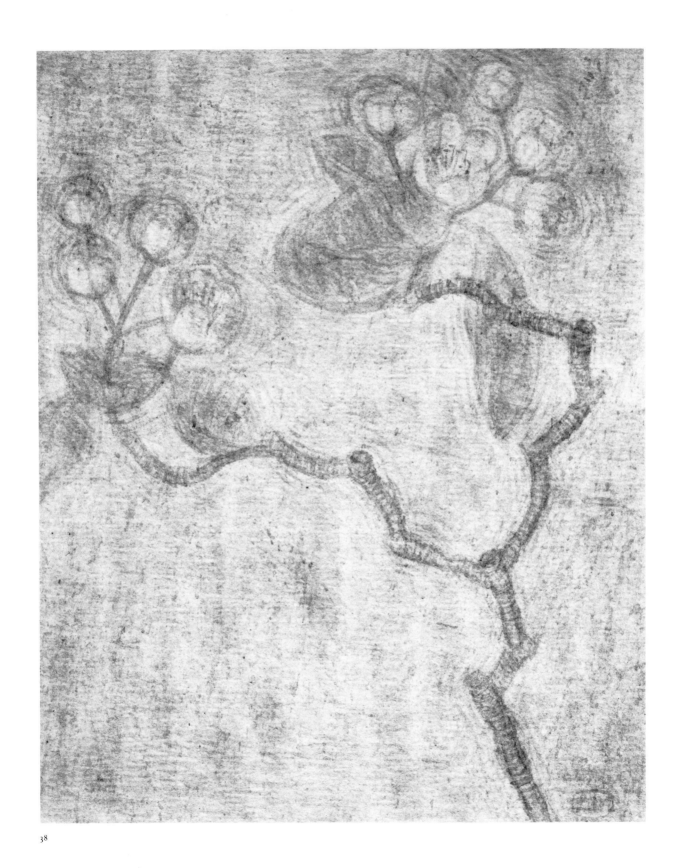

38

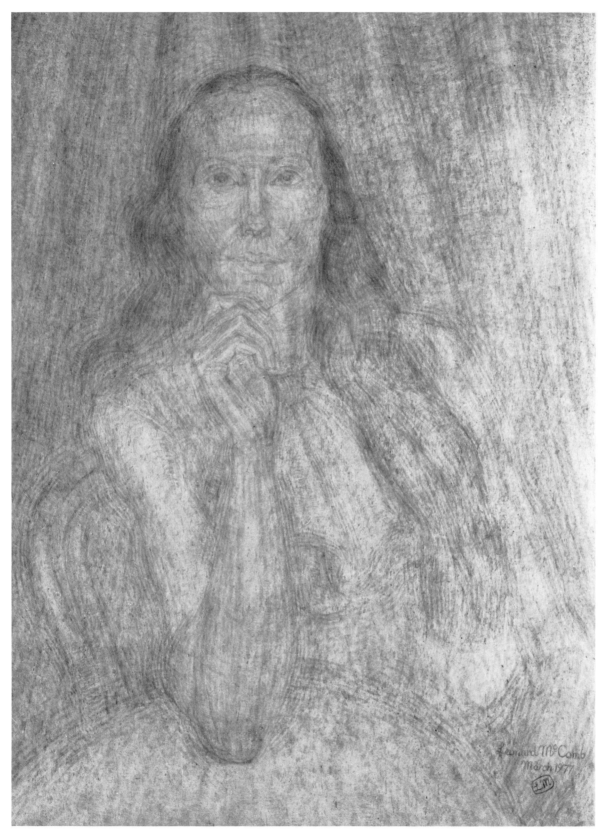

19

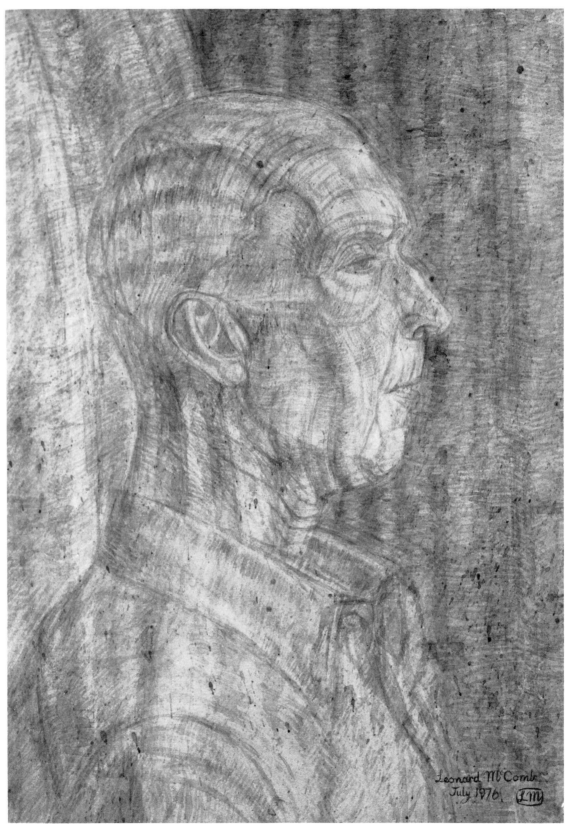

Leonard M<sup>c</sup>Comb
July 1976

14

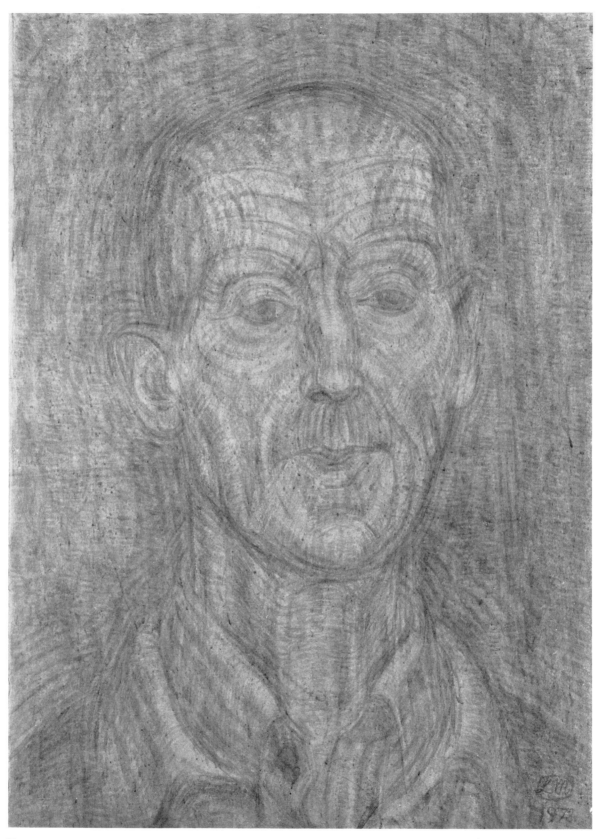

15

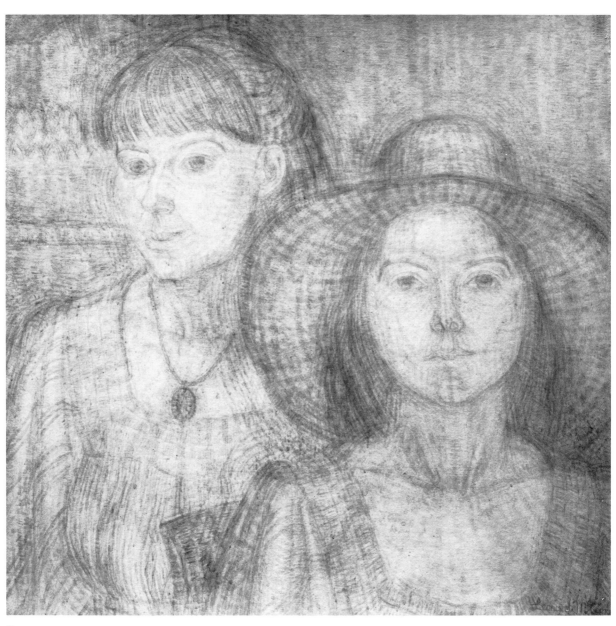

35

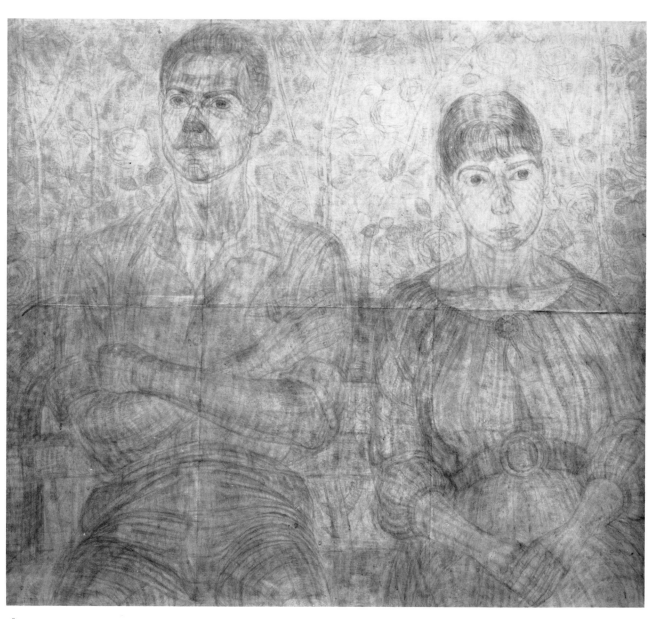

48

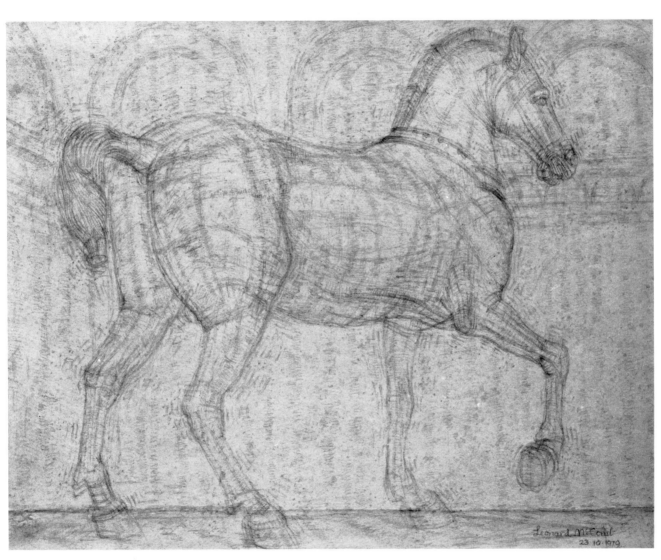

42

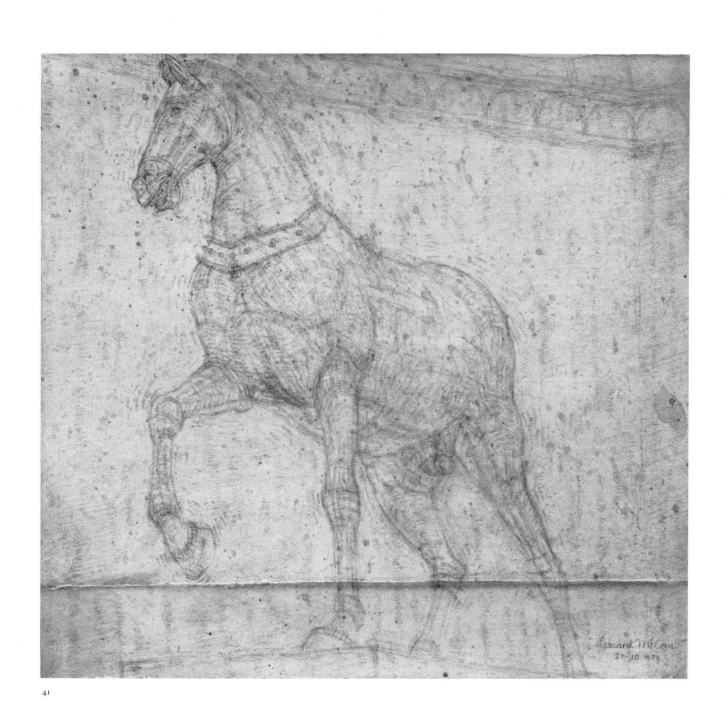

41

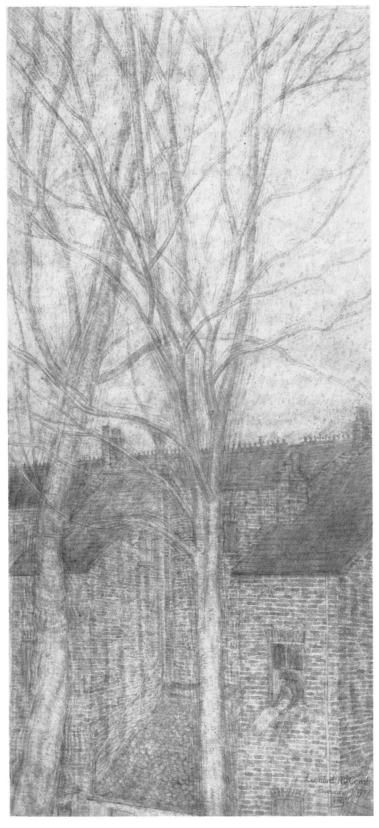

28

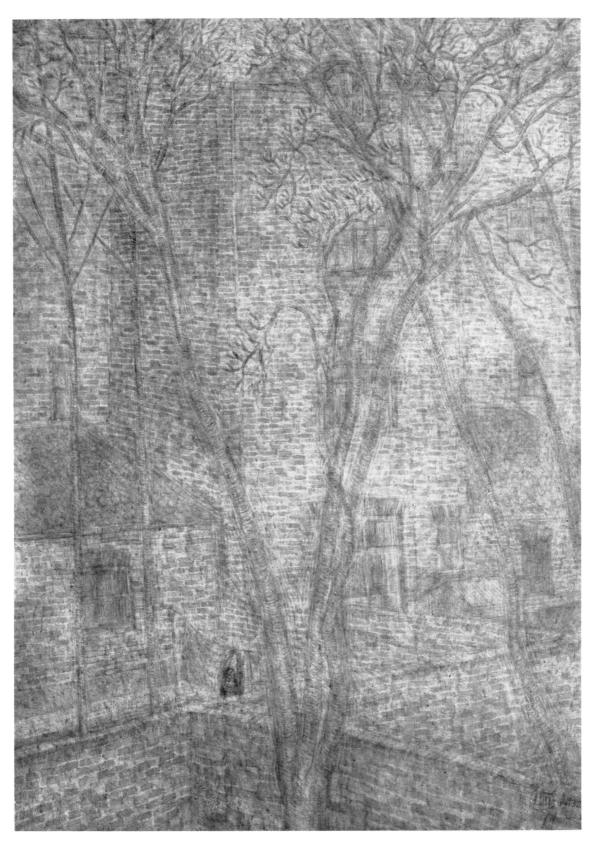

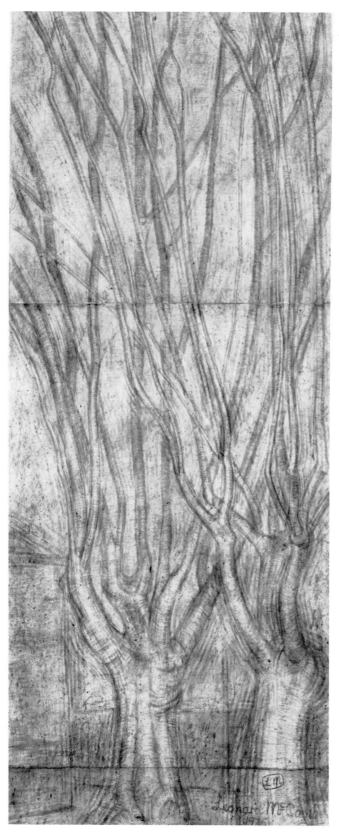

7

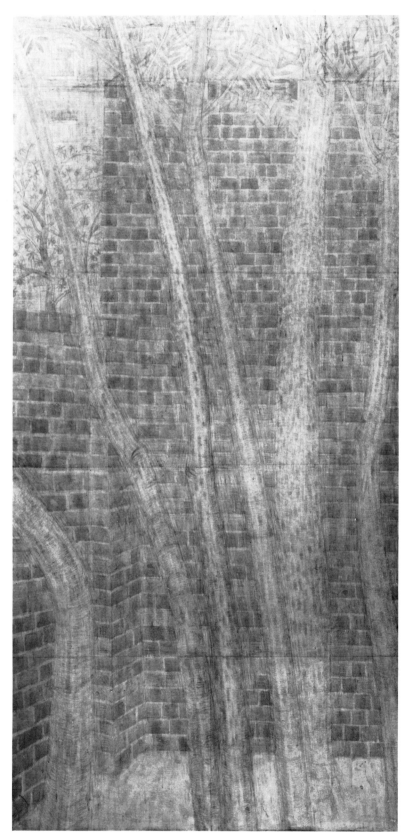

53

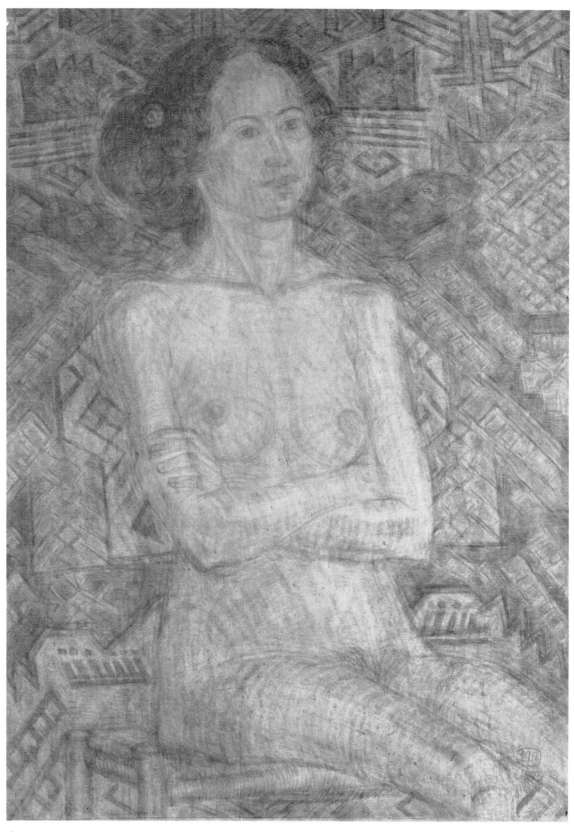

46

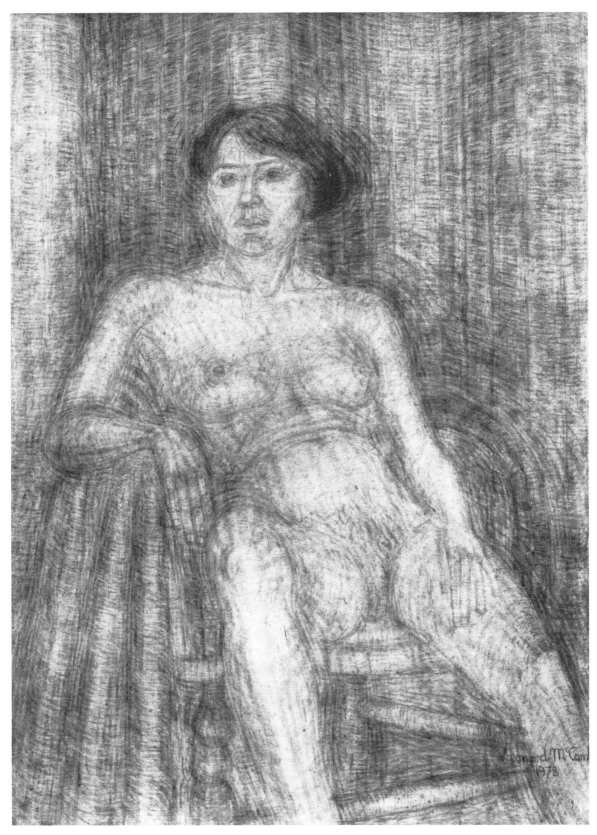

33

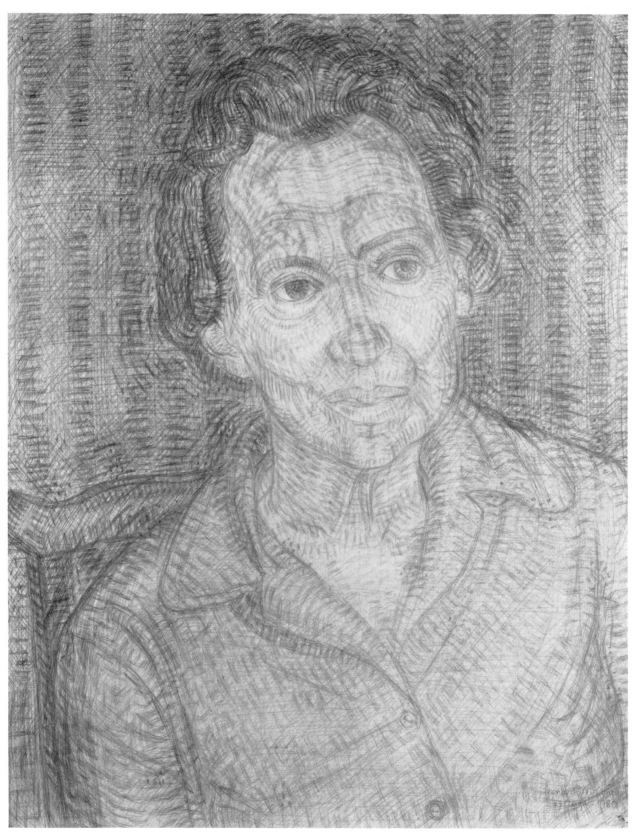

57

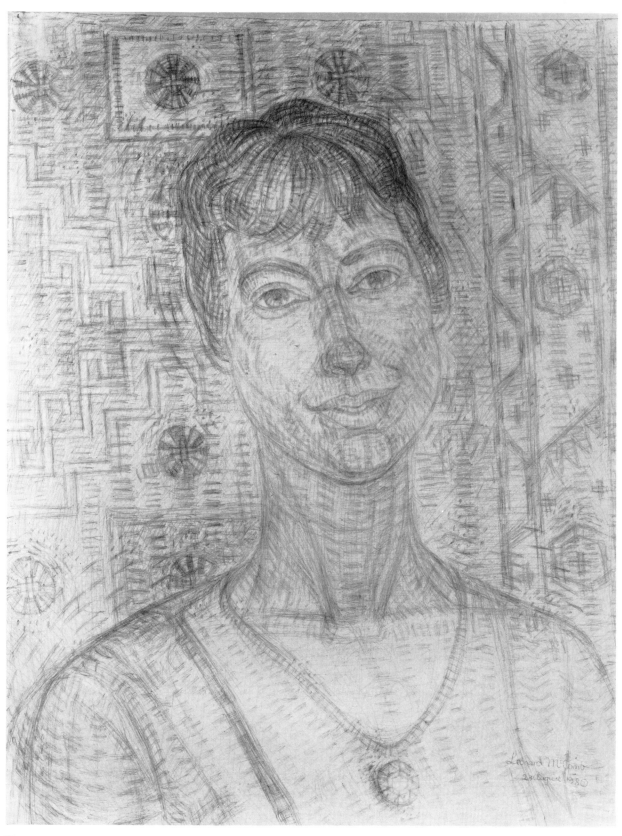

58

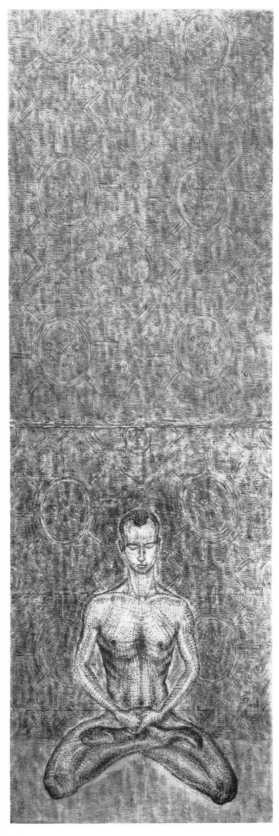

71

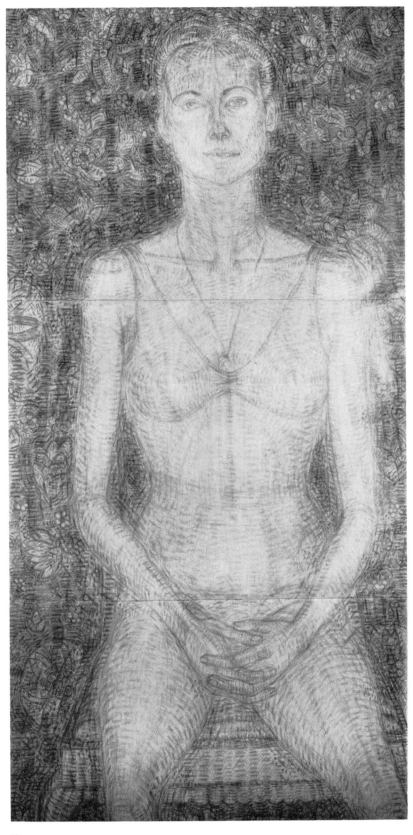

52

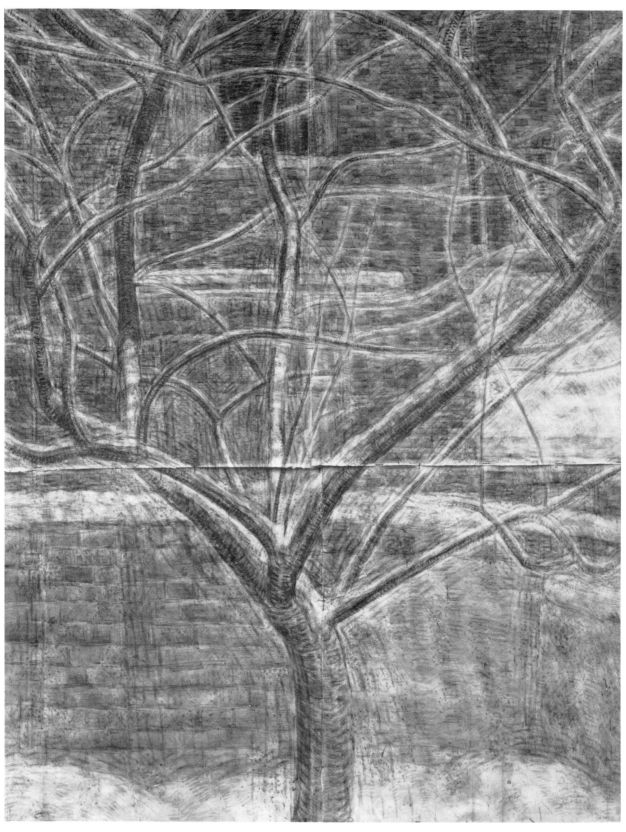

62

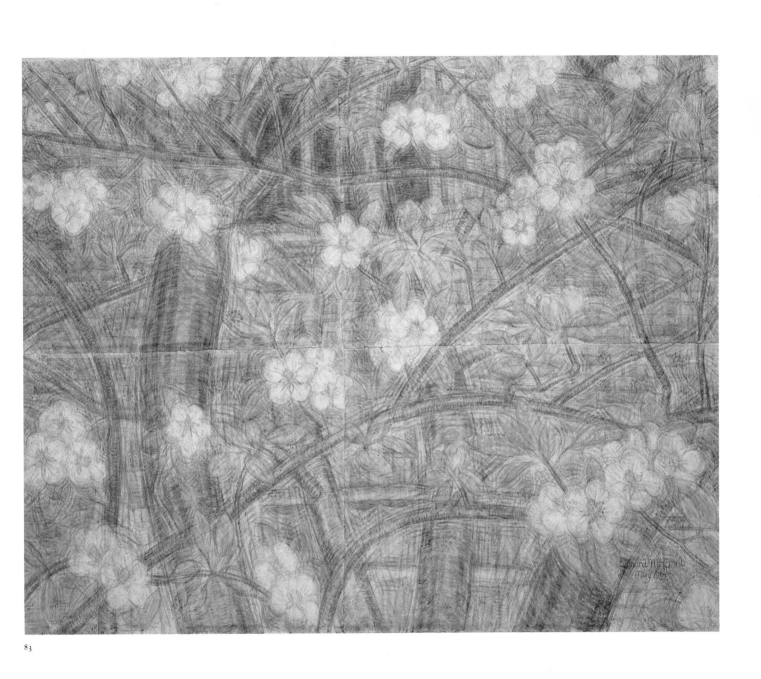

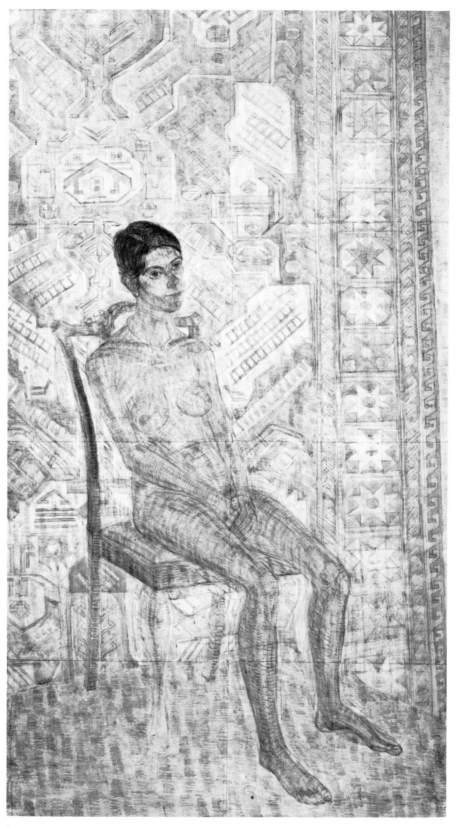

67

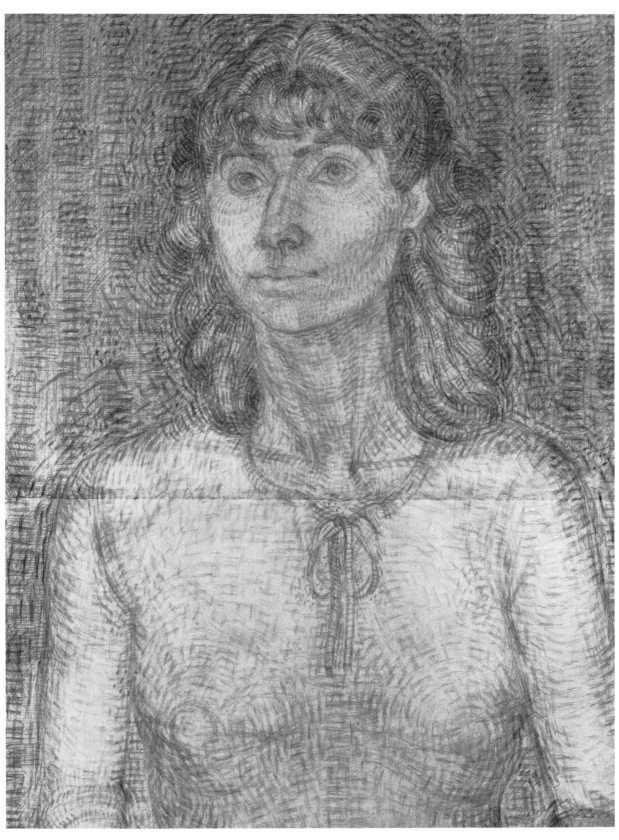

51

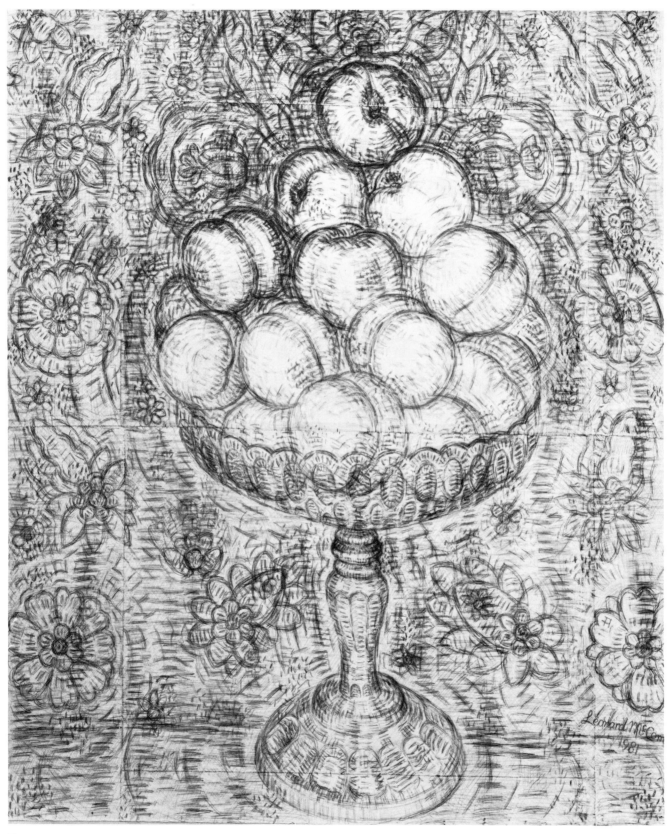

75

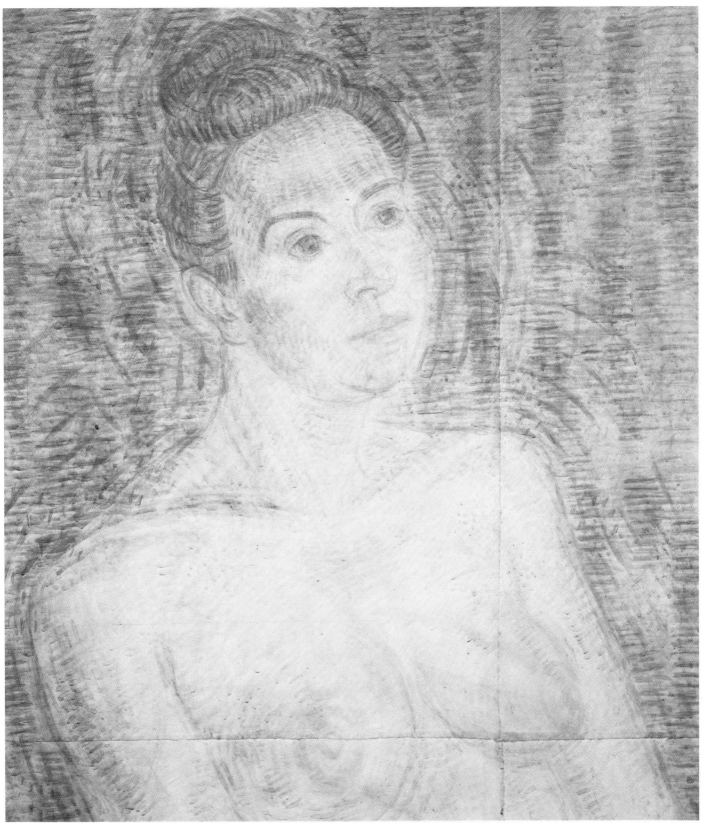

61

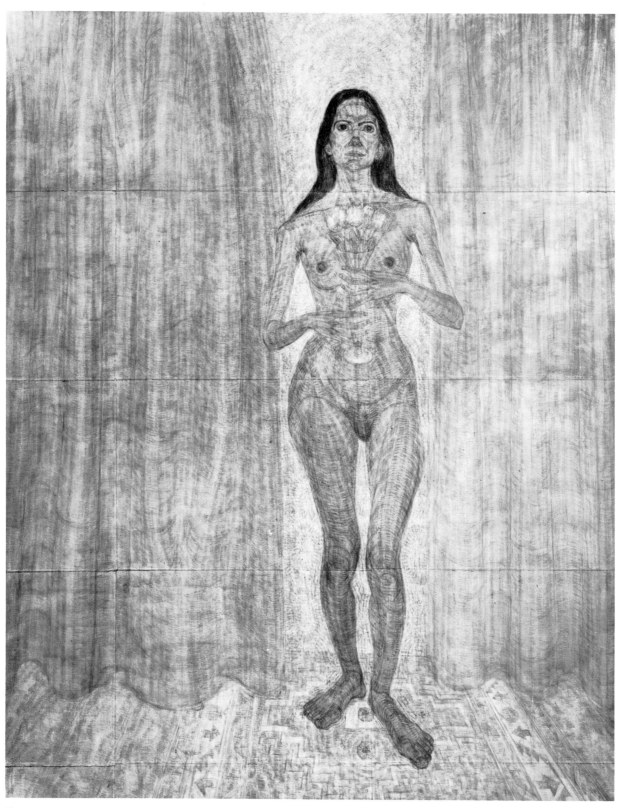

73

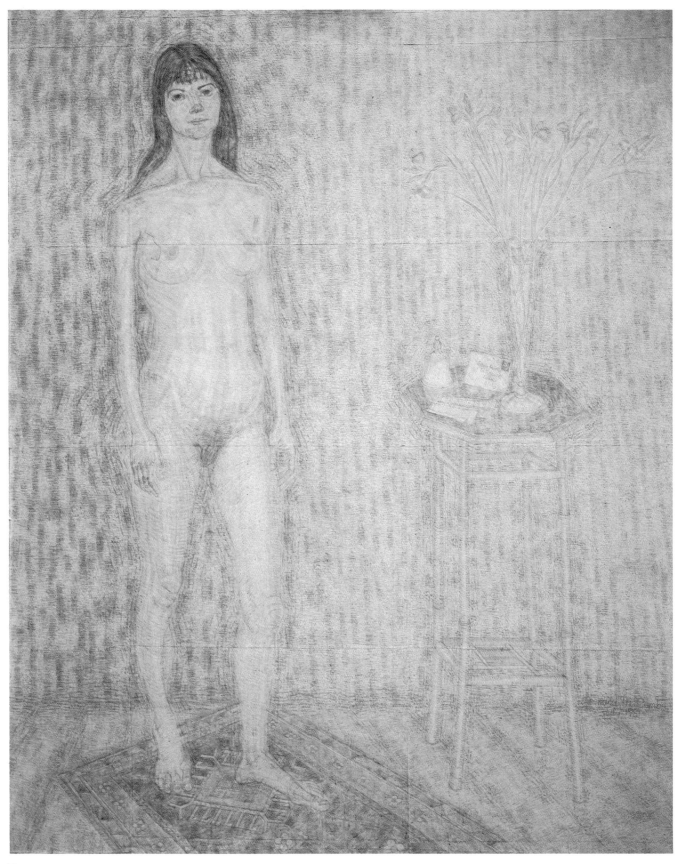

72

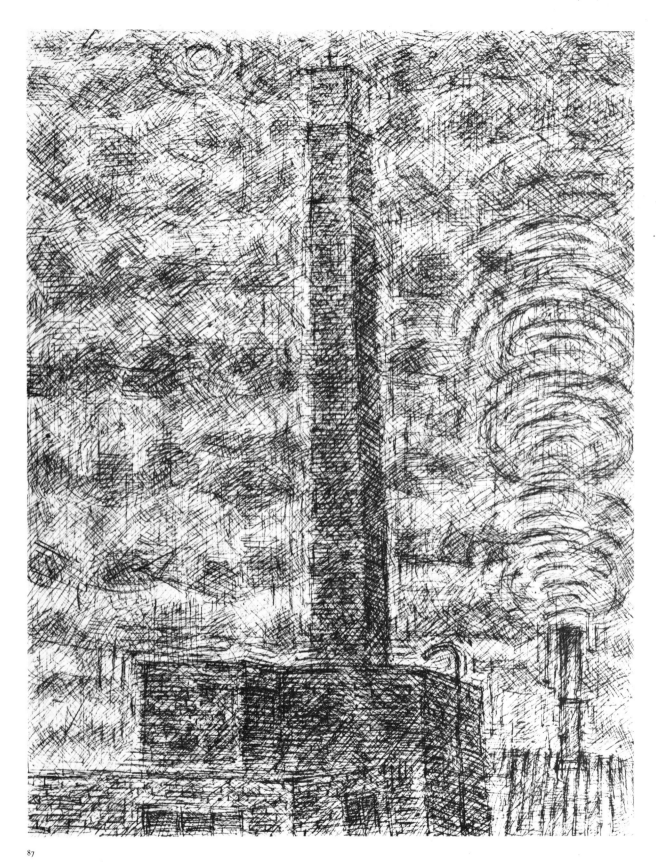

87

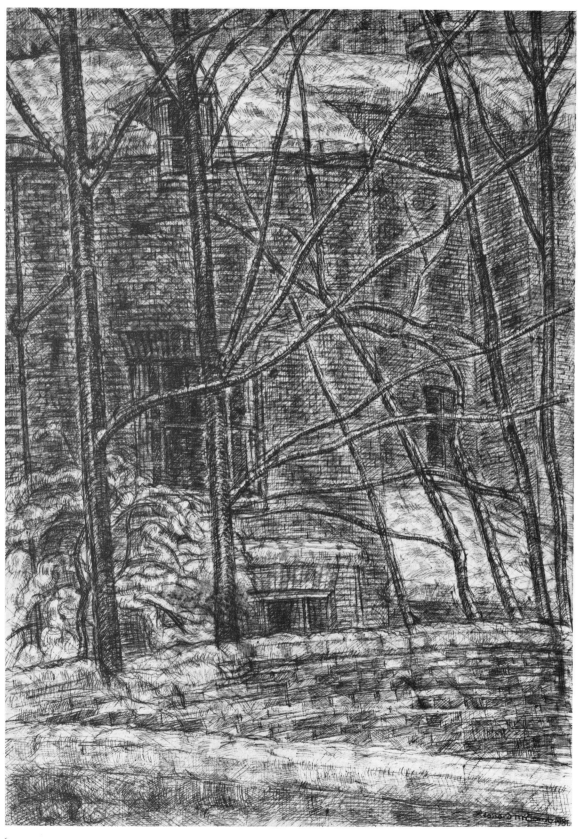

63

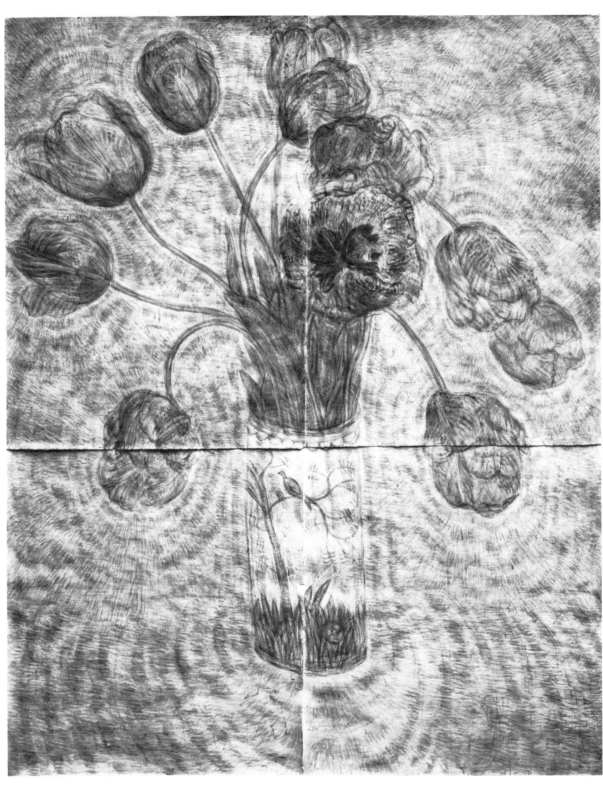

90

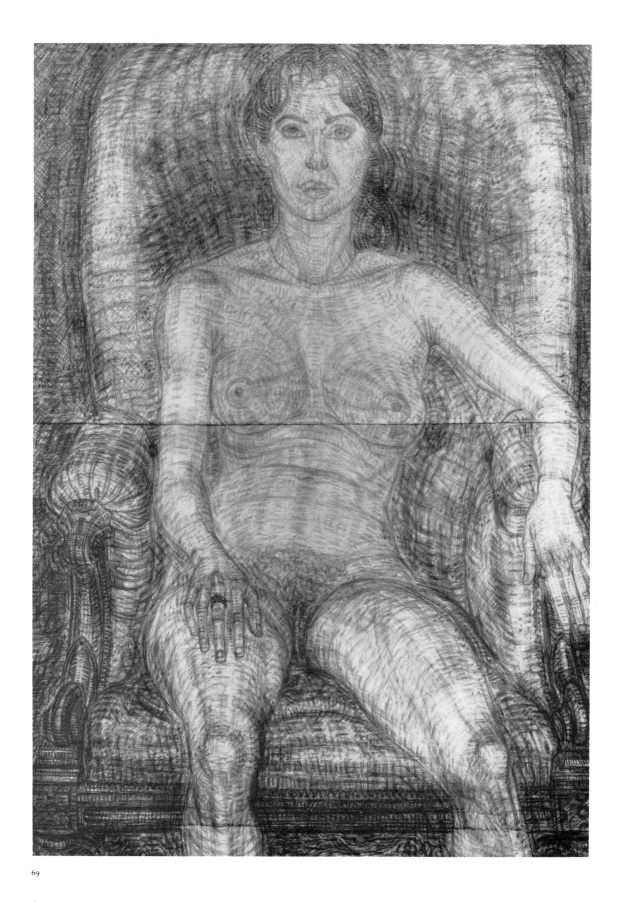

69

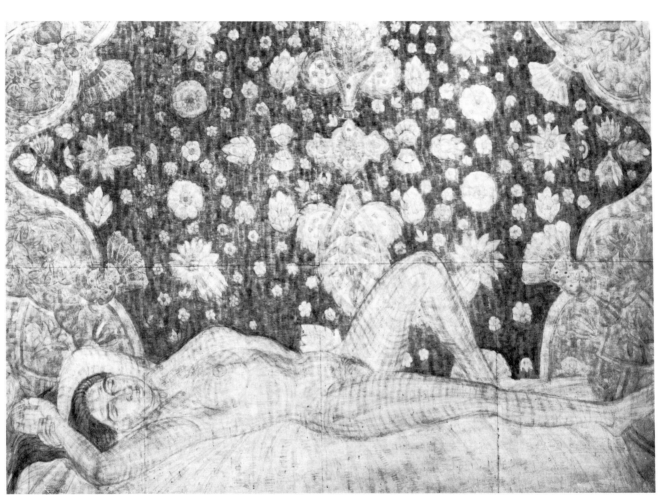

56

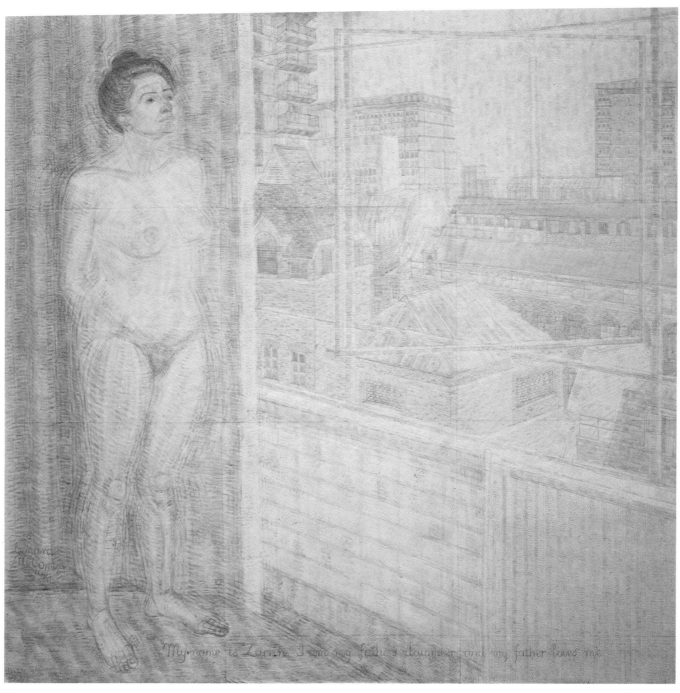

My name is Zarina. I am my father's daughter and my father loves me

68

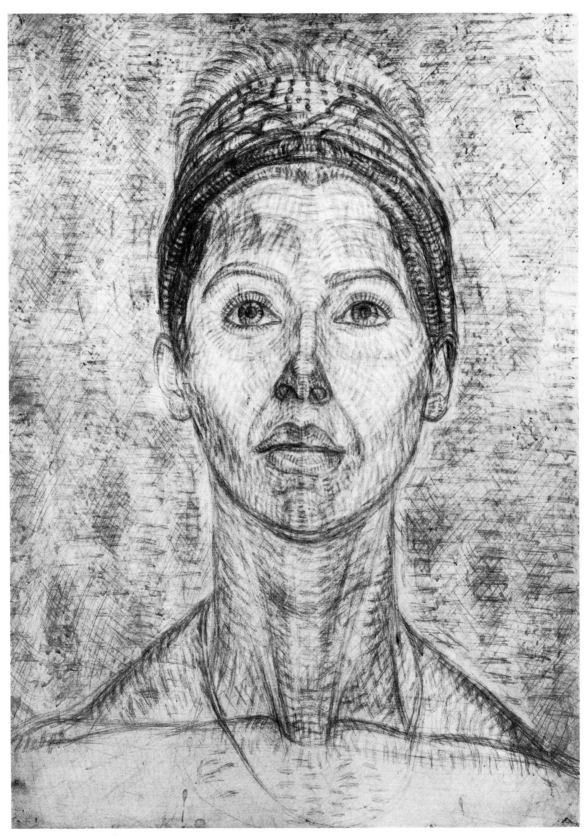

65

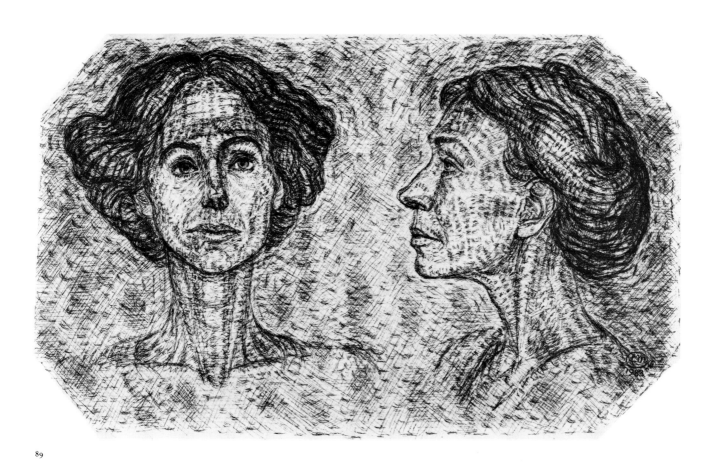

89

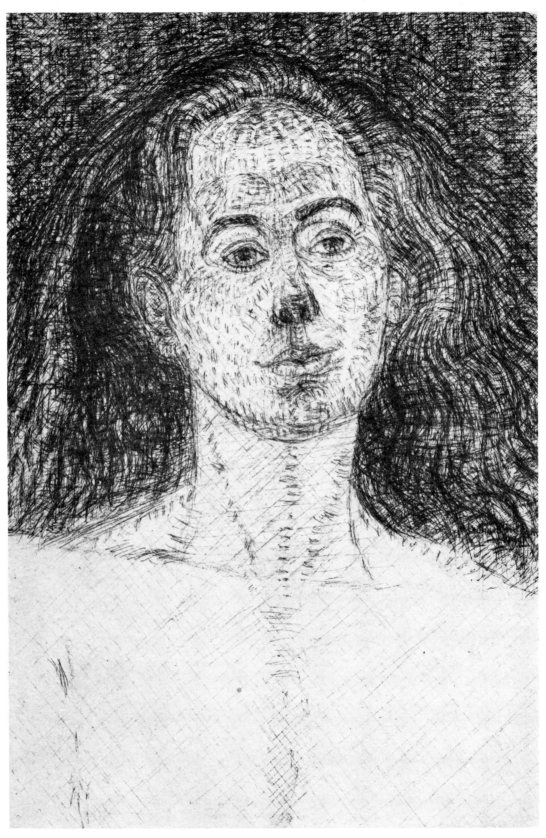

66

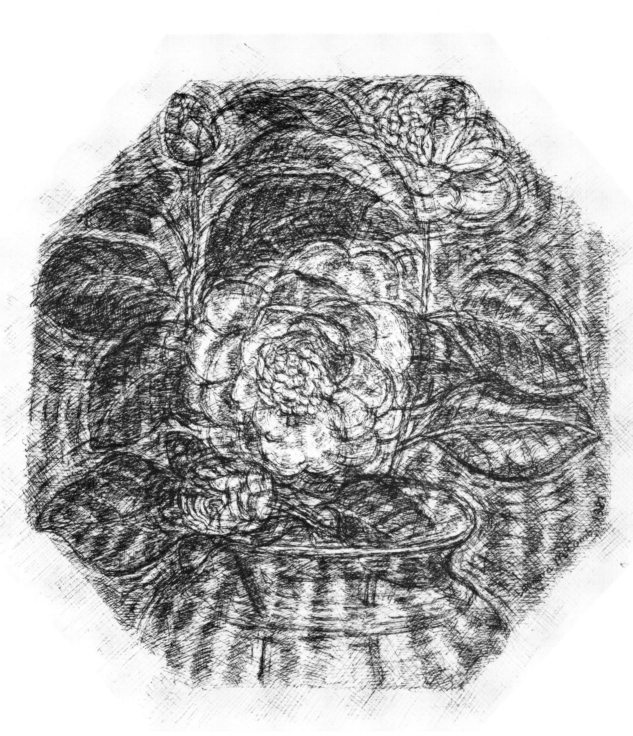

91

53

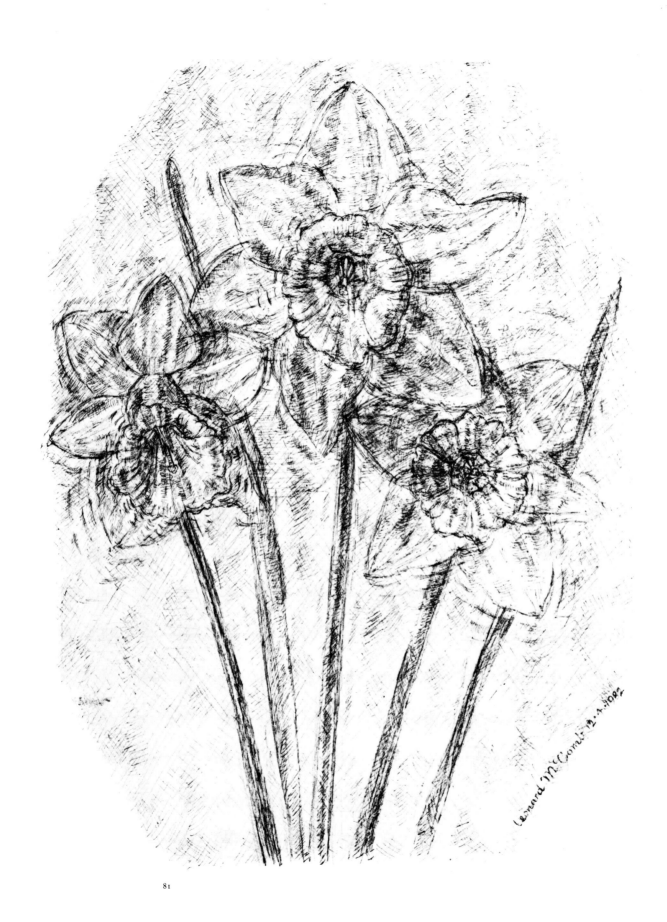

Leonard McComb B.A. 1982

81

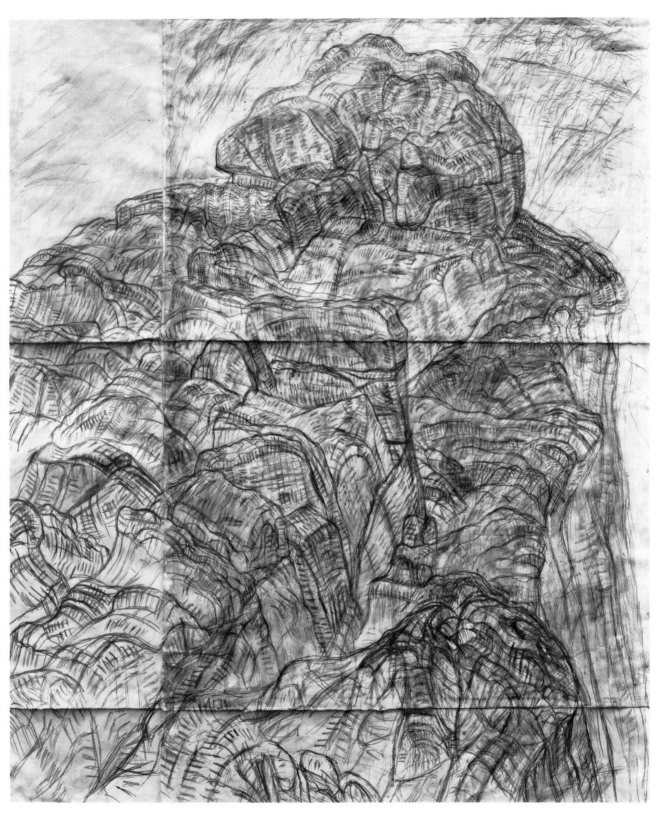

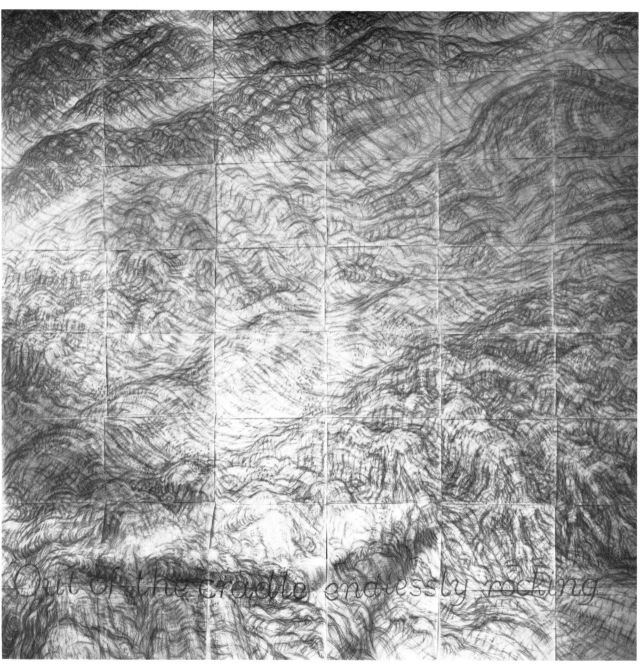

92a

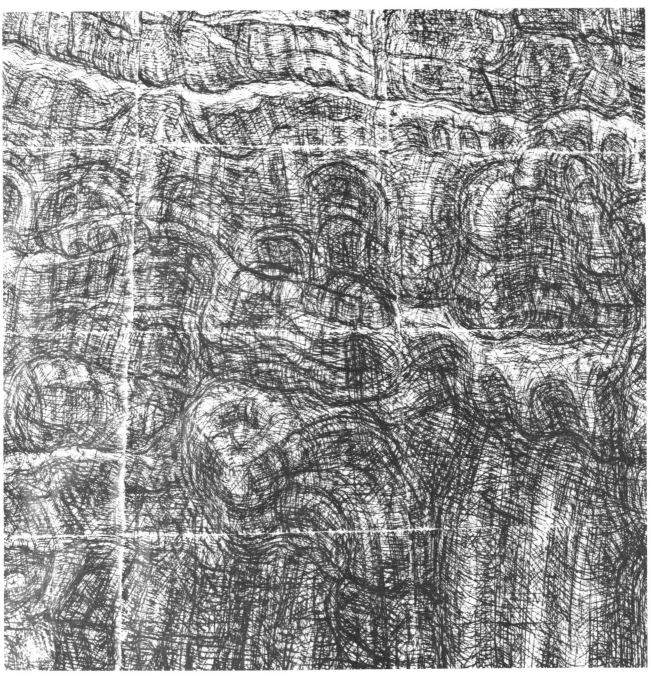

92b

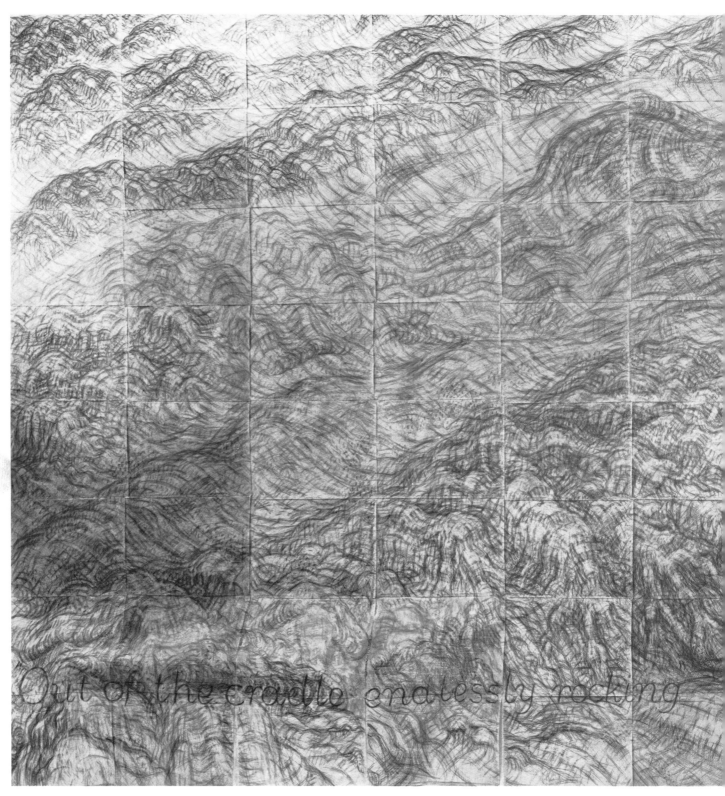

Out of the cradle endlessly rocking

92

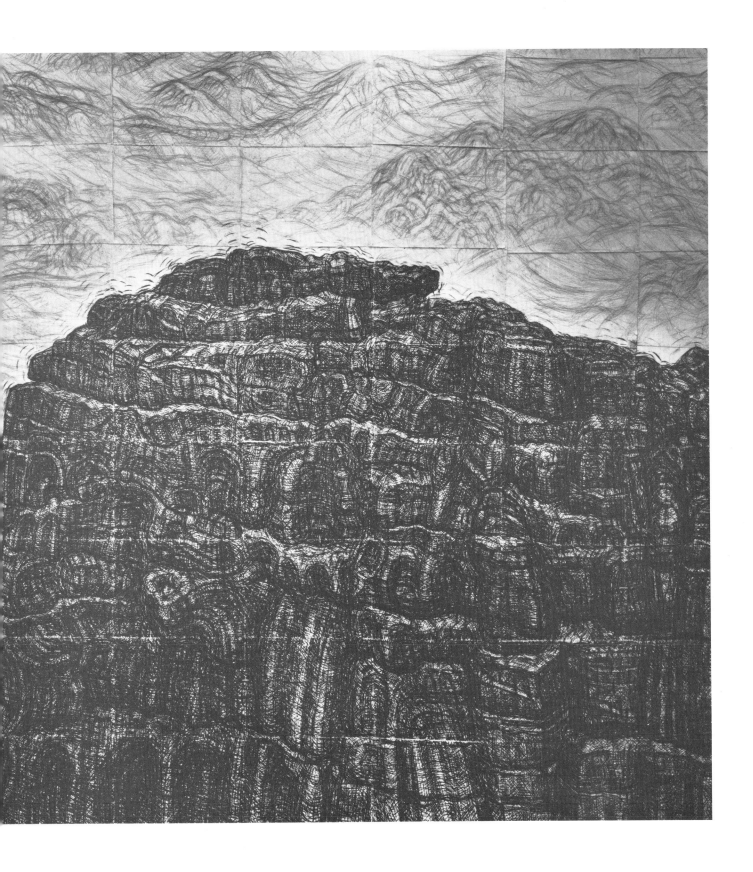

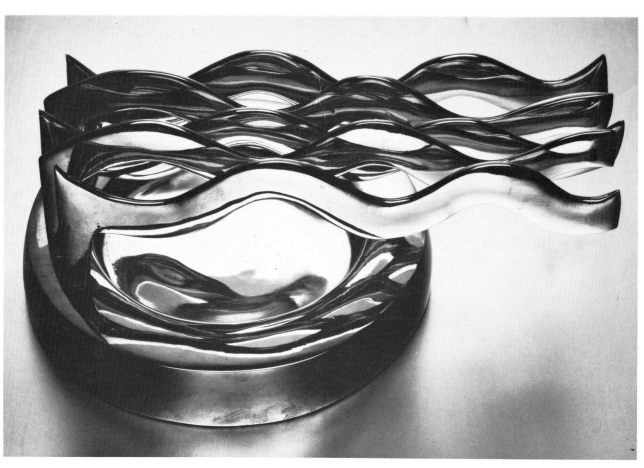

94

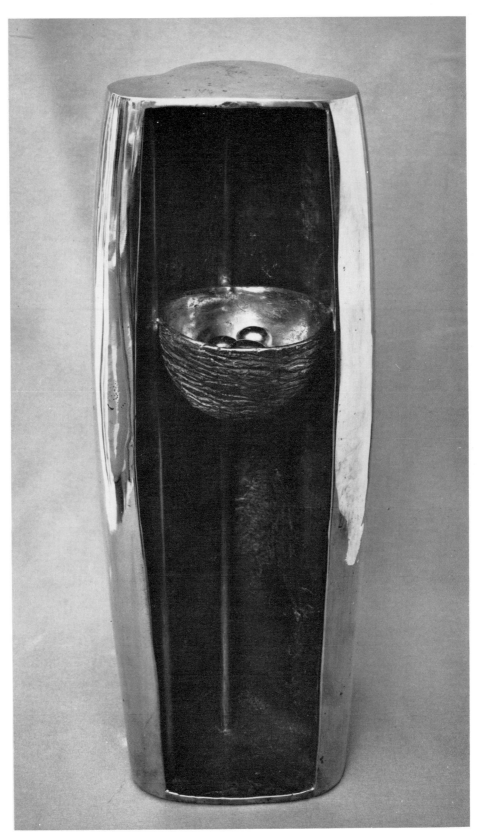

96

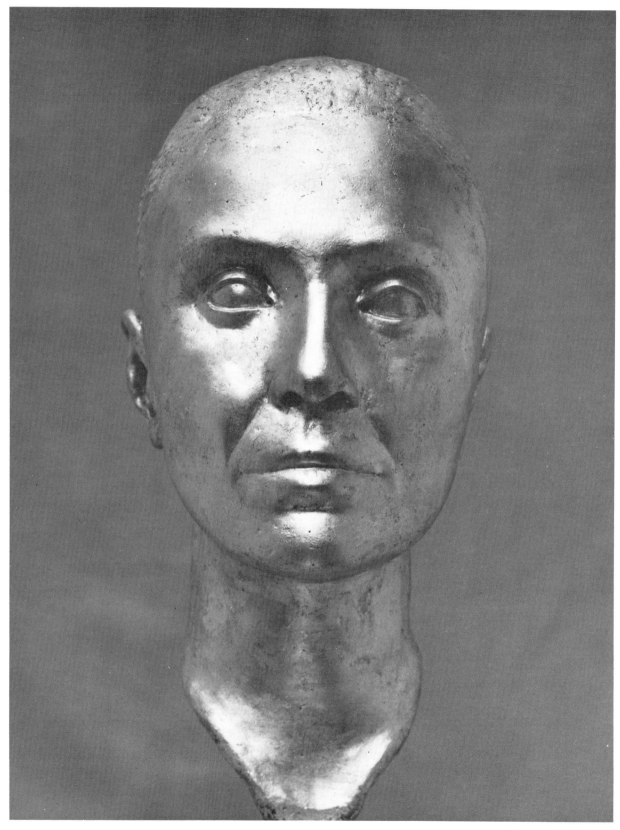

100

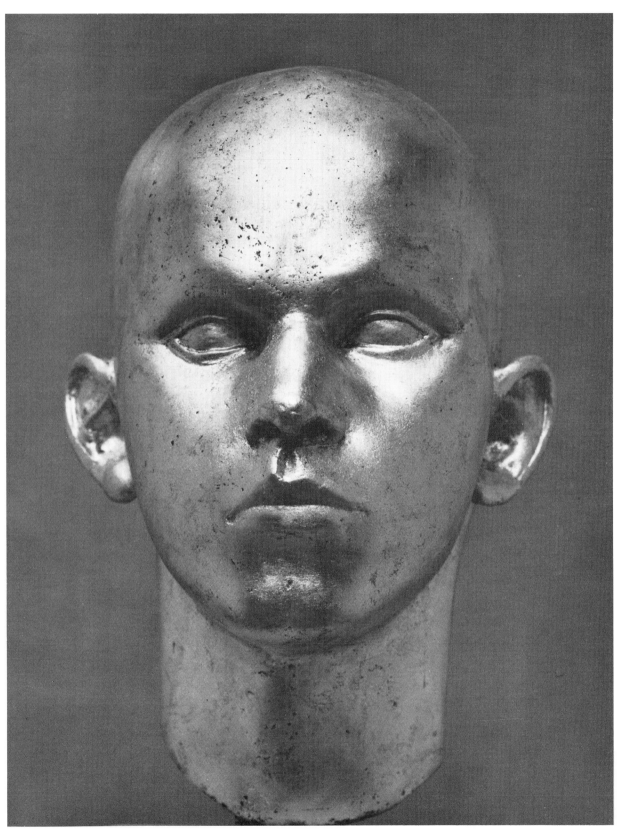

101

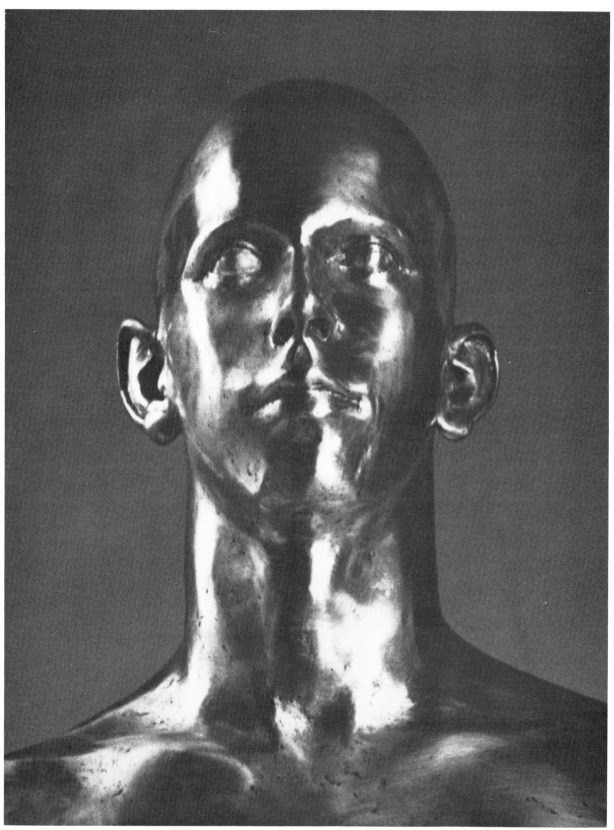

102a

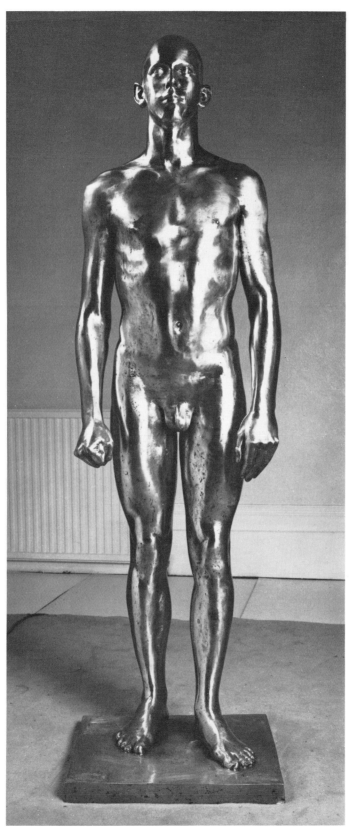

102

'ENERGY IS ETERNAL DELIGHT'   WILLIAM BLAKE

A single pebble thrown into a still pond – from the centre – the delight of the vibrations.

Nature is full of unbelievable surprises – the fingerprint.

Light is the thread of Art.

The lime-tree outside my studio has grown for nine years.

In art it is easy to be personal; the real problem is to speak to strangers.

It is the vision that matters and not the ideas.

The slow building of the watercolour is comparable to adding clay to the armature.

Powerful tension, created through dabs of coloured water.

The space cannot be separated from the beauty of the forms.

Drawing is the architecture of the spirit.

In spring is much movement, in winter stillness – art contains many opposites.

The impossibility to create a painting with a heartbeat – a lifetime is not enough time.

It is easy to begin a painting; to finish a painting is difficult – the difficulty increases.

The beauty of the late Cézannes – the top of the mountain is as a candle flame lighting the plane around.

Leonard McComb
London, September 1979

First published in 1979 by the Coracle Press Gallery, 233, Camberwell New Road, London, S.E.5. in the folder of prints 'Blossoms and Flowers.'

# LEONARD McCOMB by RICHARD MORPHET

In the winter of 1982–3 Leonard McComb was working with concentration and at considerable length on a new cast, eventually to be gilded, of a life-size sculpture of a nude standing figure. Though he had begun it twenty years before, he still sought, in an already powerful image, an ideal finality of form. Recognisably a work of our own day it spoke eloquently, too, of the art of ancient Egypt. During the same months he was at work, two hundred miles from the motif, on a detailed drawing fifteen feet high and over thirty long, of a granite rock on the coast of Anglesey and the massive waves which for centuries have advanced against it. He was also working on the five individual units, each in polished bronze and each like a prong bearing a long floating pennant, which compose a compact and at first sight almost abstract sculpture small enough to fit onto a 12-inch LP. The subject of this sculpture was the same waves, their unbroken fabric brought out by the sunlight which caught them as they raced towards the shore. The intense brightness of the bronze generates light, and thus whatever its setting the sculpture has an animation akin to that given to the real waves by the sun. Though delicate in form it conveys a sense of concentrated energy.

The outward variety of these three works is one index of the extraordinary character of McComb's enterprise. As recently as seven years ago, when he first began to rouse attention in the London art community, a straightforward description of this group of works would have sounded so improbable as only to have been imagined in a dream. And indeed, though in a different way, a sensation as of dream was what one had on visiting McComb's studio and house, where many watercolours, pale but rich, seemed to make the intensity of the observation of real life a main subject of the work, yet at the same time transmuted this into something more – a vision, broad in range and at once familiar and new. Though now more widely known, McComb's art retains this quality of dream wherever it is shown. Its fusion of an outer with an inner reality is unrelated to that of Surrealism. It is conveyed by the combination of intense concentration on particulars with a feeling for rhythm and structure that relate his motif to the wider creation. But it is conveyed also by the visible evidence of the techniques of repetition, substantiation and refinement which make the form of a McComb so striking and strange in today's figurative art. His works compel our attention because they give out an absolute sense both of assurance and of

dedication – of the artist as craftsman, image-maker and oracle. In McComb's work technique and vision combine to form a single extra-reality, and it is this which unites its outwardly contrasting forms.

Many of McComb's images are exceptionally still. No less important in them, however, is the sense of an inherent energy, to which he responds in all the forms of nature. This inner unity of theme links the gigantic drawing of rocks and sea to even the smallest and quietest of McComb's still lifes. Indeed, the work which led directly into this largest picture was a very small, minutely detailed ink drawing of daffodils in Anglesey. They are set within or against an octagonal ground which enhances the sense of formal enclosure, but are alert with life. In contrasting grandeur the Anglesey rock drawing is concerned with the power of the sea. Excited by the structure and character of the granite mass, McComb chose his angle of view to maximise the sense of its relationship with this opposed force. As much sea as possible is above the rock; in the structure of the drawing as well as in terms of representation, an insistent pressure bears down diagonally from the top left corner. Not only can one sense the imminent engulfing of the rock, but for the viewer confronting these enormous and repetitive rhythms there is a feeling of being merged personally into the elements themselves. This parallels an effect of McComb's portraits and still lifes, in which the combined intensity of his notation of appearances and of his rhythmic reiteration of marks gives the image on the paper an almost hypnotic presence – not, however, through subjection, as in hypnosis, but through reciprocal relationship with the images's presence and plastic energy.

McComb's transposition to a wall in London of the immediate sensation of standing on the edge of the ocean in Anglesey was achieved by extraordinary determination and means. The drawing is on ninety-six separate sheets of paper; of these the rock appears on thirty-six and the sea on seventy-one. McComb elaborated the sea in London from numerous drawings done on the spot, but all the rock sheets were taken to a highly developed state on the motif. He pinned four sheets at a time to a large board attached to a step ladder which he stabilised by weighting it with lumps of granite. Standing on the edge of an adjacent promontory he worked on them nine hours a day for twelve days, constantly changing the permutation of the sheets on the board and maintaining continuity between all thirty-six by being able to move horizontally or vertically

within the image at will.

Not until he returned to London was he able to see the image assembled complete. He continued by working for three months on the whole drawing in an enormous borrowed studio, establishing the general structure of the waves and making the rocks ever denser and richer by overlaying the already complex marks he had made in Anglesey. Drawing close up from step ladders or a mobile tower his aim was to intensify the sense of the rock's physical form, bringing out its vigorous internal rhythms and accentuating the different degrees of relief within its surface. By this stage, in both rock and sea, he was inventing marks; these rained down with increasing graphic freedom. Paradoxically his hand was working both to render more vivid the sense of tangible water and granite – every sea trough and rock ledge specific – and simultaneously to fuse these into an independent creation having a vital organic life of its own. In doing this the repeat structure of the sheets of paper played a part, as did the interplay between the movement of the waves and the linear channels in the rock; even the spring of the canes to which he at times tied a pencil so that he could make marks from a distance of some twenty feet made a contribution.

The contrast between the sea's shifting fluidity and the exceptional hardness of granite is a principal subject of this work, and is emphasised by the vertical drop of the rock's seaward face. On the gnarled rock surface which we see broadside on, the lines and declivities have been formed by centuries of battering by the waves. To McComb the image of this rock is a symbol of endurance, of the need to survive. The similarity with the faces of the elderly sitters of Rembrandt is hardly a coincidence. In Anglesey in the same year McComb drew a head and shoulders portrait of his mother and inscribed on it her exclamation of delight as she looked towards the sea. But in a paradox typical of McComb his rock drawing stresses the unity of rock and sea as much as it does their opposition. While working there he wrote 'the rocks are cascaded with myriads of rivulets and swirling shell spirals – black granite carved alive like a living sea'. Thus the drawing's subject is also – and doubly – *dialogue*. In nature, rock and sea are united through a cycle of movement in which one forms the other, while on the paper's surface they are united through the repeated rhythms of the artist; these, equally, construct a form which seems inevitable and complete.

Much has been written of the immersion of the great Abstract Expressionists in the material and the fields of their large canvases and in the gestural marks through which they sought and found powerful subjects going to the root of existence, at the same time revealing much about themselves. In the drawing of rocks and sea McComb's motif was explicit before work began; nevertheless its realisation has something of the character of the release and revelation of a subject whose identity cannot fully be known till it has been fused with the artist's inner life through a process of his complete identification with it. One is reminded of the famous phrase 'When I am *in* my painting . . .' written in 1947 by Jackson Pollock, in whose works writers have correctly drawn attention to vigorous internal rhythms, an inherent sense of control and a strong sense of the structure and appearance of nature. As McComb worked on the rocks and sea drawing, the expanse of which exceeded that of his own body by over thirty-two times, he was of necessity absorbed into its complex internal pulse and into the abstract reality of its individual strokes. The overpowering nature of this experience, the intensity of the work's demands on McComb's perception, concentration and control, the need simultaneously to be aware of the smallest detail and of the balance of the whole, and the grandeur of the conception and of the whole enterprise cannot be overemphasised.

Only after many months during which the drawing was further refined in sections in McComb's own studio was the process complete. It must have seemed to him as though it had concentrated or telescoped the processes of millennia by which the rock in Anglesey had reached its present shape. Yet as McComb's works go, the time spent on this drawing had not been unusually long. For the version of his 'Portrait of a Young Man Standing' seen in this exhibition is the final result of work on a sculpture which he began as long ago as 1963. As in the rocks and sea drawing, the creation of a strong identifiable image was inseparable for McComb from the precise realisation of its surface, inch by inch. Thus extended observation of a real model was only the beginning of an equally extended process of refinement, first of plaster and then of bronze, to give maximum articulation to every detail of the structure. By this means the asymmetries within this particular body (and by implication any other) are clarified, even emphasised, while in the hands – one clenched, the other relaxed – McComb's concern with both the outer and the inner life is symbolised by asymmetry of a different kind. As he told Timothy Hyman,[1] against the background of the Cuban missile crisis, the murder of John Kennedy and the Vietnam war McComb created this figure as an affirmation of survival. 'I tried to create an image of a whole person, his physical and spiritual life

being inseparably fused [and implying] the embedded capacity for powerful and gentle action, both physical and intellectual'. It is an image of youth, both vulnerable and determined – perhaps unconsciously a self-portrait of McComb in the strangely isolated situation he occupied in the 1960s. But it is also at once a portrait of a particular individual studied by McComb and a symbolic and therefore impersonal image. Its authority has a quality of permanence which while in no way obscuring its date frees it from restriction to the particular era that produced it.

In childhood and adolescence McComb was much influenced both by the countryside near his home and by the interests and beliefs of his father, a master decorator who enjoyed painting landscape and taught his son the importance of craftsmanship and of careful completeness in any work undertaken. McComb's father was interested in poetry, philosophy, folklore and magic, observed nature keenly, and believed in the need to safeguard the natural environment from the encroachments of urbanisation. Inherited by McComb, these points of view were not particularly to the fore in the art world of the 1960s and 1970s. They help explain the length of the period that was to elapse before this artist, born in 1930, was to become widely known at about the same time as some prominent artists twenty years younger. The sensibility of the English art community has grown towards McComb rather than vice-versa. His conviction that art, to be significant, must concern itself with life was of course shared by the most important artists of the last two decades; but by contrast with most of theirs McComb's work has consistently laid unambiguous emphasis on realisation of the subject, and next to none on art as a commentary on other art of its own day.

Even today when recognisable imagery often linked to a sense of the past is again to be seen on every side, it is rare to find an interesting emergent artist whose work shows so little connection with isms. This is partly because McComb's concern is more with the great tradition in Western art of earlier centuries up to the early twentieth than with a conceptual approach (so important in, for example, Pop, Minimal and Conceptual art, as well as in Cubism and aspects of Surrealism). He aims to create memorable images of general appeal, but his directness is the result also of his insistence, amid a surrounding battle of styles, on going back to nature as permanent and essential subject and source, an attitude distinctly against the grain of the period 1960–75. Also odd in these years among artists of his generation was the intention to make apparent in art 'the interlocking of the spiritual and physical', a

criterion of William Blake's which he has always consciously followed. 'In my art I try to make this oneness clear. To me it seems that this interweaving is part of the timelessness in art. The cycle of human experience is given shape therein. Some modern art appears to me as an absurd jig-saw the parts of which may be interesting in themselves and sometimes follow a trend; they will, however, never fit together. This fragmentation is very much part of the tragedy of modern man; it has resulted in his sense of personal silence being clouded'.[2]

Consistent with this certainty of aim and with McComb's imperviousness to commercial and fashionable pressures to produce swiftly, are both the visual quietness of most of his works and the patience with which he is prepared to work on any one of them over a long period (this quality of the passage of time is communicated by the form of the finished work). Neither forced nor assertive nor hermetic, they make apparent the steady and natural process of their growth, and *give out* a sense of life. All the qualities mentioned in this paragraph are features of the work of Brancusi, whom McComb admires intensely. They also relate to his experience as a student at the Slade under Coldstream, Monnington and Gerrard, three artists much concerned with patience and concentration. Important to McComb was drawing from plants and from classical sculpture in the Cast Room (subsequently dispersed) and, in particular, the opportunity to work in the sculpture studio where he accounted himself astonishingly fortunate that the model was available five days a week for ten weeks in a single pose, a situation unknown elsewhere at the time.

But though observation is of central importance to McComb at all stages of a work, this must not be taken to imply that his art is restricted to precise appearances. In 'Portrait of Zarrin Kashi overlooking Whitechapel High Street', for example, the buildings are presented in adjusted relationships to increase the formal unity, and McComb frequently makes alterations in detail from observed particulars in body or face – with the aim and effect, paradoxically, of increasing the authenticity as a portrait. He emphasises the permanent truth that art is choice; the artist must always select, and in realising the essence of a subject he has to abstract.[3] An intensely classical artist, McComb directs the spectator's awareness and never makes a mark that does not have a considered role within the work as a whole. Conversely, he will not leave a picture till every centimetre plays its part; his work stands for integration and against any sense of the fragmentary. The marks he makes are explicit individually. The movement set up among them

gives each work its own distinctive pulse. A given type of mark is reiterated at controlled intervals to act as a brake on the force of the central motif; the result is not to obscure this motif, but to endow it with a special kind of life.

At the Slade McComb was fascinated by the ritual of the studio; his own studio motifs of fruit, flowers, model or sitter are themselves approached with an ordered formality. He seems to address any subject by means of a strange combination of distance and solemnity with a penetrating scrutiny of both appearance and inward being. Each work thus conveys immediately that its subject is more than merely what we see; it is rigorous observation heightened both by inner disclosure and by a quality of universal archetype. To these dimensions in the work is added the effect of McComb's almost ritualistic procedure in another sense – the way he builds up the image from successive minute touches or strokes, almost as if reiterating a chant. The evidence of this activity has an expressive character in its own right. For all his personal insistence on the specific image McComb rejects fiercely the idea that quality in art can be correlated with the non-issue of representation versus abstraction. A major criterion which for him transcends this division is whether a work is given life by the presence in it of a feeling for nature.

For years McComb was working against the grain of the governing trends in art. But he was and remains very much part of his period in the high degree to which the finished work makes the spectator aware of the process that produced it, as well as in his concern with achieving the maximum force in a work through the most reduced language possible. Quiet though they are, McComb's images *project* themselves exceptionally, at once plastically and through the imagination. The viewer cannot separate an immediate recognition of their densely-wrought substance from a no less instinctive awareness that the driving force of this material fullness is a passionate spiritual concentration. Thus, whether human model or coastal rock, flowering branch or pyramid of fruit, the image has a sheer *presence* which cannot be ignored.

There are two contemporary English artists of other generations with whose work McComb's seems to me, however unexpectedly, to have close affinity – Cecil Collins (b.1908) and Richard Long (b.1945). All three artists insist on the central inspiration of nature and on the need to safeguard and respect it. Each exhibits before nature the opposite of arrogance, celebrating it with a kind of wonder. Moreover as image-makers they are far from forcing their works on the attention; immediate impact is not their goal.[4] In no way assaulting the subject, they re-present it in art with an impressive combination of gentleness and subtlety of touch with firmness of form. Through the work of each there runs a delight in inner rhythm and interval. Each is fascinated by the primal origins of the world, by the mystery of time, and by magical traditions which have been handed down. The simplicity of the work of each is the vehicle for a certain profundity. Indeed, self-effacing though all three are, each is directed by an absolute inner certainty and confidence which seems impervious to fashionable criticism and has the quality of an inner vision. The work of all three points both to nature and to art, intensifying our awareness of both.

McComb's work stands in an unusual relation to both painting and sculpture. For thirteen years he did not paint in oils, yet by choosing instead the most insubstantial of media for working on a flat surface he achieved a material density and a sense of immutable solidity which stand on equal terms with more tactile paintings. One reason is his technique in watercolour of using innumerable subtle touches of colour to build up a remarkable richness of texture having a special luminosity and depth. But no less important is the central role played in McComb's work in all media by his essentially sculptural feeling for form in space. For McComb forms do not simply occupy space; they exert an energy which radiates outwards from them. Its source is the dynamic not of movement but of a living inner tension which he perceives in all natural matter from stone to plants to people. Thus in building up such an image, whether in touches of watercolour or in plaster for bronze, he seeks always to realise a vitality which depends on concentration of form. This concentration emphasises the sensation of the process in nature of the growth which, within each form, has led to its present fullness (as well, often, as promising its further development). It is through McComb's treatment of its outer, containing surface that we are given a sense of the inner structure of a form. Whether in two or three dimensions the definition of this surface is critical to his whole undertaking. From this surface the form radiates outwards, seeming steadily to emanate light in a manner which material texture readily explains but which does not seem to be accounted for by this factor alone. In drawings and watercolours the surfaces of bodies and of fruits are traversed by delicate parallel contours which isolate individual forms from the background (even as these are integrated with the surrounding space by often just-perceptible concentric lines which track outwards from figure or object like waves). There is something almost mystical about the view of creation which is conveyed by contemplation in this way of its individual

elements standing silently before us in space. They are viewed with a distinct respect, even a certain awe, as they body forth the principle of nature and its ever-renewed potential.

Thus important though the surface is to McComb, he is equally concerned with inner force and with outward relationships. Both testify to the continuous activity of nature, and to the essential *interaction* between its elements. For McComb the meaning of a motif cannot be grasped unless one senses both its particular individual character and its active participation in the natural order as a whole. Thus while he emphasises the three-dimensional discreteness of individual forms, his constant instinct towards interrelation requires that they should in some sense merge. That is why one's powerful sense of stasis in a McComb is justified only up to a point. In the studio of Brancusi, which McComb visited while at the Slade, there is an intense stillness, and Brancusi's clear sculptural forms, like McComb's, were endlessly refined. Yet, as McComb writes, this stillness in Brancusi is 'compact with energy, light, life, compact with living forces, and therefore fluid'. In McComb's own work the combination of a living tension of form with the expansiveness of each form into the world around it achieves a parallel fluidity. The glowing reflection of his bronzes recalls those of Brancusi, 'which shimmer the air around them with the light of the muses'.[5] In the works on paper the lines of vitality which radiate from each form, blurring its precise frontiers even as they emphasise its particularity, testify to McComb's view that there are no edges in nature and that above all the artist must not freeze the subject. Asked his view of Ingres, McComb replied 'much as I admire his clarity and precision I find his forms somewhat static, and consequently the relationship between the forms and their space stilled. Flux and change are qualities of line'.[6] McComb feels his work took an important step forward in 1975 when he realised that he must not consider the shapes in his paintings and sculptures as – ultimately – finite. In resolving henceforward to pursue a fluid solution in each work he had at last co-ordinated his vision as between painting and sculpture.

McComb's view of nature as an unbroken system of interacting energies leads to a heightened sense, when viewing any of its parts, of what that part has been, what it will become, and its relation to the greater whole. The rocks and sea drawing gives a sense of the sea's magnitude, but on a calm day in Anglesey McComb wrote 'The winds are almost absent. The sea rocks by in undulations of ochres and greens – such gentleness, ferocity sleeping, blinking in sunlight. Around as I work,

tiny sea birds feed on sea weeds, their alive beauty an inspiration. How many birds hearts beat the world over?'[7] As artists so dissimilar as van Gogh and Beuys have done, McComb seems often to wish to relate each specific motif to the whole of existence, and certainly sees his individual work as an artist as integrated into the pattern of nature, rather than as a detached view of it. He has been influenced fundamentally by Melville's *Moby-Dick* and by the poems of Whitman. 'I've observed the rock in all kinds of gale conditions', he writes, 'completely covered by tides, and washed by mountainous seas – it still stands. Yet, like Ahab, it is determined by the forces of God, for it is in his divine wisdom that everything moves, changes. The rock is also a symbol of the creative spirit, the ceaseless restlessness of the artist's life, always looking seawards. Throughout the three month's work in that quiet studio with the white roses blooming, blowing beside the window, the opening lines of Walt Whitman's poem "Sea Drift" which I first read when I was a student at the Slade have continually come back to me so that I have decided to write it on the base of the completed drawing – "Out of the Cradle Endlessly Rocking". Later in "Autumn Rivulets" he concludes his poem "Miracles" –

"To me the sea is a continual miracle,
The fishes that swim – the rocks – the motion of the
     waves – the ships with men in them.
What stranger miracles are there?"[8]

Although McComb always seeks a universal relevance, he is averse to generalisation. Not only the features of models in the studio, flowers in a vase or the pattern in a carpet are presented in great detail, but in his largest work he makes every separate valley in the shifting sea a known place, carefully wrought, and no two units in his small gleaming bronze of these same waves catching the light are the same. The phrases inscribed in his works have a corresponding particularity. Along the lower edge of 'Portrait of Zarrin Kashi overlooking Whitechapel High Street' one reads in a bold script 'I am my father's daughter and my father loves me'. Each such inscription seems both personal and universal. McComb quotes with admiration some lines of William Blake:

'For Art and Science cannot exist but in minutely
     organised Particulars
And not in generalising Demonstrations of the Rational
     Power,
The Infinite alone resides in Definite and Determinate
     Identity.'[9]

At the centre of McComb's art lie many paradoxes.

Indeed one of the sources of its power is the reconciliation within each work of qualities which in principle are opposites. Almost withdrawn in their lack of clamour, his images yet project themselves, with extraordinary and insistent authority. Conspicuous for its stillness, his art takes as central subject the vital and endless change of nature. In his hands watercolour, a fragile and delicate medium, evokes strength and endurance, both in the power of his images and in the experience of life that these record. Through gentleness lies ultimate vitality. Yet in stressing the very permanence of a motif such as the rock, McComb dwells also on its transience. 'I can never see nature except in terms of complex movements. The tree for example is real – apparently permanent – yet every second it grows and changes . . . I try to incorporate this in my work'.[10] The more McComb defines the reality of nature the more he displays the contrivance of art – in itself a central subject, yet in his work made strangely one with nature's processes. 'Imaginative truth is the only truth, and yet nature is all-powerful'.[11] A northern and a Celtic artist, focussing on the particular, fascinated by rhythm and line, and giving his figures in many ways a vital awkwardness of presence that is part of their intensity, he yet looks always to the south, to the sun and to his also central theme of light, and seeks above all the rewards of control – a grand but also succinct unity between all his parts.

This theme of resolution, of unity, is the central message of McComb's art, for it gives both tangible and symbolic form to his affirmative philosophy of life. His portraits increase our awareness of the adversities many of his sitters have suffered, but the spirit these works convey is one of acceptance fortified by optimism. An unusually high proportion of McComb's portraits are of people who are conspicuously young or old, or who are living far from the land of their birth but who are tenacious in their sense of identity. In every case the portraits communicate their subjects' experience and their hope. McComb celebrates the promise of early life, is fascinated by breadth and zest of working experience – particularly of any lifetime spent in a demanding craft or trade or in extensive travel – and specially respects the combination in many elderly people of calm acceptance of the inevitability of declining energy with an undefeated spirit. 'Art', he has observed, 'is the celebration of God's radiance; death is also an expression of his radiance'.[12] His work witnesses to the rightness of the natural order, seeing all stages in the cycle of life as a unity. At the centre of this vision is his reassertion of human dignity. As Timothy Hyman has written,[13] 'in work after work, McComb has been able to transform and transcend any life-room origins, and to recreate the Body as an act of faith'.

In today's complex pattern of art it is notable that McComb's works have no disturbing undertones. As indicated above this is far from meaning that they ignore unpleasant realities. It is specifically in the face of these that McComb's insistence on wholeness at once of form and of feeling is a positive act.[14] The steadiness of the sitter's gaze, the even intensity of McComb's, the fullness of the realisation of each natural form, and the integration of these with every touch in detail and with a work's whole rhythm – all these are aspects of a unity the through-and-through character of which seems ultimately metaphysical. In the art world it seems strange to talk of faith, but this is the vital quality which McComb's whole activity declares. It sustained him through nearly two decades of substantial public ignorance or incomprehension of what he was trying to do, as well as through recurrent illness which returned with unnerving force just when the largest drawing of rocks and sea was at critical mid-point. It inspires him to rejoice, even in adversity, in the many blessings of life. It is an attitude in which it is impossible to disentangle the element of deep-seated trust that life will work out well from that of unwavering determination to realise and communicate his vision. Its great strength lies in its directness, for it is grounded not in intellect but in intuition. There are no clever ideas in McComb's work but there is much wisdom.

As anyone who works in the art community has reason to perceive, today's life is one of pressure and rush. Visitors to this exhibition will at once discover that McComb conceives a different world. Its celebration of living forms reemphasises the need to preserve the balance and the richness of the natural environment, while its calm underlines the positive value, the vital role, of quiet and contemplation.

The spirit which is at the heart of McComb's work cannot be separated from his treatment of light, which throughout his art plays a key role, both structural and symbolic. Reflective surfaces or the brilliance of paper can be expected to activate light, but in McComb's work it seems to be generated more dynamically. The sculptures receive and give it out across exteriors refined to a point of formal tension, and the drawings and watercolours through an interweaving of accents which gives the emission of light an active pulse. In the small 'Sunlight on Sea' sculpture the play of light on the individual members seems to turn them into a single substance. In the works on paper the hundreds of individual dabs of colour have a tendency, particularly in the ground against which a figure is set, to coalesce into

a kind of haze, alive with activity and always curiously radiant. This is an effect sometimes seen in the subdued richness of Islamic carpets; with their characteristic unity-in-complexity these are often used by McComb as portrait backgrounds. 'The experience of light', he notes,[15] 'is playing an increasingly important role in the paintings, where I try to give the feeling of the forms carrying their own light as in a candle flame'.

McComb's special concern with light is yet further evidence of the visionary nature of his art. It is an art which transforms the detail of the world around us, even as this is celebrated in itself. Each of McComb's works gives an extraordinary sense of the actual presence of the motif. But it transposes the motif into McComb's own world of imagination, presenting it with a concentration that gives it a role going beyond the facts of period and place. Through an obsessive interest in the particular, McComb, like early Samuel Palmer, makes apparent an attitude to life as a whole. The direct, vigorous and slightly archaic verbal expression of both also makes evident the insistence of a vision refreshingly independent of worldly sophistication. McComb steeps himself in the physical process of making a work. While always maintaining control over the image he in a sense loses himself in a work's rhythm and inner life; its physical form thus expresses his emotion as directly as it simultaneously articulates the image. Yet through the very process which gives it enduring form the motif is also dissolved into an abstract energy by which the subject is linked to the substances and forces of nature as a whole. This energy is perceived by McComb as both physical and spiritual. The radiance which emanates from every form (as both waves and light) is a manifestation of his conviction of the active interdependence of the two. In insisting on this radiance McComb affirms the principle of permanent renewal inherent in the cycle of nature and of life. Remarkable for its positiveness, his art celebrates this cycle in all its phases and all its parts.

NOTES

1. Timothy Hyman, 'Leonard McComb: Body and Spirit', *London Magazine*, August–September 1982, pp. 64–73; nearly identical text reprinted, with different selection of illustrations, under same title, in *Artscribe*, 37, October 1982, pp. 38–43.

2. From notes on Blake written by McComb for Timothy Hyman, 1982.

3. 'When I regard a form it is a living organism. The problem in painting is to make the picture a whole living organism. To do this successfully one must select and create an abstraction, an equation for nature's energies' (McComb to the author, 1982).

4. Collins's central archetype is the holy Fool, whose task in life is symbolised by the title of one of his paintings, 'The Quest'. In a letter of 14 May 1983 about the present exhibition McComb writes 'I do not wish the exhibition to be seen as a retrospective. I have not yet reached the promised land. Since 1975 I have been pointed somewhat in its direction. If it is God's will, perhaps in the next ten years I will make my best works'. In answer to questions from the author in 1982 he wrote 'The humility and quietness of Morandi are exemplary. He does not complain about his condition, he does not try to impress us, he speaks to us in gentle terms. His bottles, bowls, lamps which others would pass by become alive in his work. They take up their identity only in relationship to each other; – the painting. In their light they whisper to us the possibility of heaven on earth'.

5. McComb to the author, 1982, in reply to questions.

6. Ibid.

7. Postcard to the author from Anglesey, 16 April 1982.

8. Letter to the author, 30 September 1982.

9. William Blake, *Jerusalem*, Plate 55, lines 60–64.

10. McComb to the author, 1982, in reply to questions.

11. McComb in conversation, September 1982.

12. Letter to the author, 17 April 1983.

13. In 1982 article cited above.

14. Along with Morandi, cited in an earlier footnote, Cézanne has been a special source of inspiration to McComb, who wrote in 1982 in reply to questions. 'A Cézanne apple is a particular living shape, so that you can weigh it in your hand. Its surface is round and firm. It has light within it and it generates it around. It has its own space, so that you can walk it around. It is dabs of colour and tone which are full, subtle and resplendent. It is canvas. It is a slippered wave on an ocean of stillness and movement. It is all these and more – it is a paradox of the most wonderous complexity. No 20th Century artist loved nature so much and painting so much. Touch him where you may his sensitive and robust nature rings true. D.H. Lawrence was right: Cézanne was pure in spirit. A spirit embracing life and looking at death. Giotto, Rembrandt, Vermeer are his company. His last Mont Sainte-Victoire painting reigns quietly over the planes of 20th Century painting. Two inches of its surface have enough energy for a thunderstorm. Many painters have journeyed around its borders, many have written about it and tried to explain it. None has climbed it – nor is it possible to do so. It is a living sphinx.'

15. Letter to the author, 17 April 1983.

BIOGRAPHICAL OUTLINE

| 1930 | Born Glasgow, 3 August. Father a master decorator and keen amateur landscape painter. |
| 1930–34 | Lived Northern Ireland. |
| 1934 | Family moved to outskirts of Manchester. |
| 1945–47 | Junior Arts School, Manchester. |
| 1947–48 | Commercial Art Studio, Salford (also 1950–51) |
| 1948–50 | National Service as Medical Orderly, R.A.F. |
| 1951–54 | Miscellaneous jobs including freelance designer. |
| 1954–56 | Regional College of Art, Manchester. |
| 1956–59 | Undergraduate, Slade School of Art, London. Work divided between painting and sculpture. |
| 1959–60 | Postgraduate in sculpture, Slade School. |
| 1960–64 | Full-time teacher in drawing, painting and sculpture, West of England College of Art, Bristol. |
| 1964–77 | In charge of Foundation Studies, Oxford Polytechnic. |
| 1977–83 | Part-time teaching at the Slade, Goldsmiths College, Royal Academy Schools, Canterbury and Winchester Colleges of Art and Sir John Cass College. |
| | Lives and works in South London. |

## OUTLINE OF WORK

|  | Up to 1975 consistently destroyed most of his work. |
|---|---|
| 1960–66 | Drawing and sculpture (both carving and modelling). Figure subjects, and abstractions from fruit and trees. |
| 1962 | Began work on 'Portrait of a Young Man Standing' (definitive bronze version completed 1983) and other portrait heads. |
| 1966–70 | Sculpture; landscape painting in oils. |
| 1971–72 | Figure drawings. |
| 1973 | Resumed work in watercolour. Copied Michelangelo, Turner and Cozens in British Museum and Ashmolean Museum, Oxford. Watercolours of fruits, trees and landscape in South of France. |
| 1975 | Began making monochrome watercolours. |
| 1977 | Increased colour and scale of drawings and watercolours. |
| 1982 | Began large rock/sea drawings, portraits and new sculptures. |
| 1983 | Resumed oil painting, May. |

## SELECTED EXHIBITIONS

| 1976 | Selected by R.B. Kitaj for inclusion in *The Human Clay*, Hayward Gallery, London, August. |
|---|---|
| 1977 | Awarded Jubilee Prize, Royal Academy Summer Exhibition. |
|  | *British Painting 1952–77*, Royal Academy of Arts, London, September–November. |
| 1979 | One-man exhibition, *Blossoms and Flowers*, Coracle Press, London, September–November. |
| 1979–80 | Artists' Market, Warehouse Gallery, London. |
| 1979–80 | *The British Art Show* (Arts Council exhibition touring to Sheffield, Newcastle-upon-Tyne and Bristol), December–May. |
| 1980 | *Aperto '80*, Venice Biennale |
|  | *The Arts Council Collection*, Hayward Gallery, London, July–August. |
|  | *More than a Glance*, Arts Council group exhibition, Graves Art Gallery, Sheffield, October–November, and tour of England ending April 1981. |
| 1981 | *British Sculpture in the Twentieth Century*, Part 2, 1951–80, Whitechapel Art Gallery, November–January 1982. |
| 1982 | *British Drawings and Watercolours*, British Council exhibition in People's Republic of China. |
|  | *Hayward Annual 1982: British Drawing*, Hayward Gallery, London, July–August. |

## SELECTED BIBLIOGRAPHY

David Brown, 'The Watercolours of Leonard McComb', *Arts Review*, 28 September 1979, pp. 510–511.
Timothy Hyman, 'Leonard McComb: Body and Spirit', *London Magazine*, August–September 1982, pp. 64–73; nearly identical text reprinted under same title but with different selection of illustrations, in *Artscribe* 37, October 1982, pp. 38–43.
Leonard McComb, text included with the suite of six printed works, *Blossoms and Flowers* (of which the frontispiece was finished by the artist in watercolour), Coracle Press, London, autumn 1979. Edition of 150 copies, with 50 artist's copies.

## PUBLIC COLLECTIONS

Tate Gallery, London; Arts Council of Great Britain; British Council; Manchester City Art Gallery; Swindon Museum and Art Gallery.

## CATALOGUE OF WORKS IN THE EXHIBITION

*Where works are reproduced the page number is shown at the end of the entry*

1
EGYPTIAN SCULPTURE 1975
watercolour and pencil
19 × 27 cm
R.B. Kitaj Collection
page 4

2
TULIPS 1975
watercolour and pencil
25 × 33 cm
Private Collection
page 5

3
PREGNANT NUDE 1975
watercolour and pencil
28.8 × 20.2 cm
The Arts Council Collection
page 6

4
ORANGES ON GLASS STAND 1975
watercolour
29.5 × 25.5 cm
Collection: The Artist
page 12

5
APPLES ON GLASS STAND 1975
watercolour
27 × 26.5 cm
Collection: The Artist
page 8

6
BARBARA WITH SUNHAT 1975
watercolour
71 × 54.5 cm
Collection: The Artist
page 13

7
TREES IN CUCURON 1975
watercolour
70 × 28.5 cm
Collection: The Artist
page 28

8
PORTRAIT OF BARBARA 1975
watercolour
35 × 27 cm
Collection: The Artist

9
GRAPEFRUIT ON GLASS STAND 1975
watercolour
30 × 27 cm
Collection: The Artist

10
TREES IN BATTERSEA PARK 1975
watercolour
27 × 26.5 cm
Collection: The Artist

11
HILL IN CUCURON 1975
watercolour
52 × 56.5 cm
Collection: The Artist

12
APRICOTS FROM THE LUBERON 1975
watercolour
29 × 25 cm
Collection: The Artist

13
SEATED NUDE BACKVIEW 1976
watercolour
72 × 55 cm
Collection: The Artist
page 15

14
MR. EDENS I 1976
watercolour
39 × 28 cm
Collection: The Artist
page 20

15
MR. EDENS II 1976
watercolour
39.5 × 29 cm
Collection: The Artist
page 21

16
ARTIST'S SISTER ANNE 1976
watercolour
71 × 54 cm
Private Collection
page 16

17
RHODODENDRON 1976
watercolour
40 × 21 cm
Collection: The Artist

18
PORTRAIT OF JOHN 1976
watercolour
44 × 35 cm
Collection: The Artist
page 14

19
PORTRAIT OF BARBARA 1976
watercolour
29 × 24 cm
Collection: The Artist
page 19

20
SEA SHELLS 1976
watercolour
53.5 × 53.5 cm
Collection: The Artist

21
PLUMS 1976
watercolour
50 × 54 cm
Collection: The Artist

22
BARGES ON THE DANUBE 1976
watercolour
29 × 40 cm
Collection: The Artist

23
PEACHES IN GLASS BOWL 1976
watercolour
33.5 × 33.5 cm
Collection: The Artist
page 9

24
DAFFODILS IN VASE 1976
watercolour
69.5 × 36 cm
Collection: The Artist
page 10

25
MRS. LILLIAN KENNETT 1976
watercolour
81 × 55 cm
Trustees of the Tate Gallery
page 11

26
PORTRAIT OF BARBARA 1977
watercolour
80 × 57.5 cm
Collection: The Artist

27
SEA AT ANGLESEY 1977
watercolour
20 × 29 cm
Collection: The Artist

28
BACKGARDEN SOUTH LONDON 1977
watercolour
79.5 × 37 cm
Collection: The Artist
page 26

43
HORSE SAN MARCO III 1979
pencil on prepared paper
28 × 33 cm
Collection: The Artist

44
HORSE SAN MARCO IV 1980
pencil on prepared paper
78 × 116 cm
Collection: The Artist

45
RHODODENDRON ON TABLE 1979
watercolour
56 × 56 cm
Collection: The Artist

46
PORTRAIT OF TALLY 1979
watercolour
79.5 × 58 cm
Collection: The Artist
page 30

47
CHERRY BLOSSOMS 1979
watercolour
59 × 80.5 cm
Collection: The Artist

48
PORTRAIT OF MELISSA AND WILLIAM
1979
watercolour
145 × 163.5 cm
Collection: The Artist
page 23

49
CLIFFS OF ENGLAND SUSSEX I 1979
watercolour
240 × 58.5 cm
Collection: The Artist

50
CLIFFS OF ENGLAND SUSSEX II 1979
watercolour
240 × 58.5 cm
Collection: The Artist

51
PORTRAIT OF LOUISE 1980
pencil
141 × 79 cm
Collection: The Artist
page 39

52
PORTRAIT OF PIPPA WYLDE 1980
pencil
180 × 99 cm
Collection: The Artist
page 35

53
GARDEN TREES SOUTH LONDON 1980
watercolour
242 × 119.5 cm
Collection: The Artist
page 29

54
NUDE BY WINDOW WHITECHAPEL 1980
watercolour
211.5 × 151.5 cm
Collection: The Artist

55
NUDE LYING ON CARPET 1980
watercolour
121 × 213.5 cm
Collection: The Artist

56
ZARRIN SLEEPING 1980
watercolour
152 × 213.5 cm
Collection: The Artist
page 48

71
HUGH IN LOTUS POSITION 1981
watercolour, pen and ink
274 × 91 cm
Collection: The Artist
page 34

72
PORTRAIT OF SYLVIA PASELLA 1981
watercolour
243.5 × 195.5 cm
Collection: The Artist
page 43

73
WOMAN CARRYING TULIPS 1981
watercolour
243.5 × 195.5 cm
Collection: The Artist
page 42

74
PORTRAIT OF MISS EMILY LEE 1981
pencil
18 × 13 cm
Private Collection

75
PEACHES IN GLASS STAND 1981
biro and pencil
120 × 120 cm
The Arts Council Collection
page 40

76
SKULL I 1981
pen and ink
14 × 17 cm
Collection: The Artist

77
CITYSCAPE 1981
pen and ink
19 × 25 cm
Collection: The Artist

78
TWO SKULLS 1981
pen and ink
29 × 16 cm
Collection: The Artist

79
NUDE IN ARMCHAIR 1982
pencil
188 × 129 cm
Collection: The Artist

80
TREES IN SOUTH LONDON PARK 1982
pen and ink
29 × 18.5 cm
Collection: The Artist

81
DAFFODILS ANGLESEY 1982
pen and ink
16 × 22 cm
Collection: The Artist
page 54

82
NUDE ON CHAISE LONGUE 1982
watercolour
165 × 115 cm
Collection: The Artist

83
BLOSSOMING APPLE TREE 1982
watercolour, pencil and ink
110 × 140 cm
Collection: The Artist
page 37

84
ROCK AND INCOMING SEA ANGLESEY
1982
watercolour and pencil
112 × 78 cm
Collection: The Artist

SCULPTURES

97
FRUIT FORM 1983
23 × 13 × 13 cm
bronze on Portland stone
Collection: The Artist

98
TWO FORMS 1963–1983
23 × 21 × 15 cm
bronze on Portland stone
Collection: The Artist

99
THREE TREE FORMS 1963–1983
225 × 68.5 cm circular section
bronze
Collection: The Artist

100
GLORIA 1965–1983
46 × 22 × 18 cm
Polished bronze and gold leaf
Collection: The Artist
page 62

101
ULI NIEMEYER 1960–1983
46 × 22 × 22 cm
polished bronze and gold leaf
Collection: The Artist
page 63

102 and 102a
PORTRAIT OF A YOUNG MAN STANDING
1963–1983
175 × 48 × 48 cm
Polished bronze and gold leaf
Collection: The Artist
page 64 and 65

103
SYLVIE LEBOULANGER 1983
26 × 10 × 8 cm
bronze and gold leaf
Collection: The Artist

104
BOWL 1983
59 × 36 cm
Polished bronze
Collection: The Artist

details 92a and 92b illustrated
on pages 56 and 57

## LENDERS TO THE EXHIBITION

Arts Council of Great Britain
Coracle Press Gallery
Trustees of the Tate Gallery
Edward Brewis
William Brewis
Jeffrey Camp
A. Gittel

Eleonora Grubert
Halina Grubert
Timothy Hyman
R.B. Kitaj
Anne Lee
Karl Simmonds
Private Collections

All works are on Royal Watercolour Society handmade paper, mounted either on acid-free board or cotton stretched over wood support.

In addition to the listed works there will be shown working drawings, sketchbooks and a Folder of prints 'Blossoms and Flowers' from the exhibition at Coracle Gallery, 233, Camberwell New Road, London, S.E. 5. 1979.

# POSTWORD

The contemplative, even meditative qualities so evident in the work of Leonard McComb may seem out of place at a time of such dramatic realignment in contemporary art. Yet within this quietness there is an assertiveness. As transcriptions of the perceived world, McComb's drawings and watercolours of figures, still lives, landscapes and seascapes go far beyond surface incident to reveal a heightened structure and substance which is in a sense visionary. In his insistence on the direct experience and knowledge of nature McComb has worked consistently within a longstanding pictorial tradition which in its combination of observation and spirituality is particularly British.

To have chosen such a path has inevitably meant a degree of isolation. There have been no previous opportunities to see any large body of McComb's work save for the one small solo exhibition held at the Coracle Press Gallery in 1979. The reason for this lies in McComb's own exacting standards – up until 1975 he consistently destroyed most of his work – and in the fact that for seventeen years, until 1977, he had worked as a full-time teacher in art schools, for the last thirteen as Head of Foundation Studies at Oxford Polytechnic. His influence as a teacher was considerable but, of course, cannot be shown in this exhibition. It was inevitable that during this time teaching should have consumed much of his energy.

Since 1977 McComb has taught only sporadically and this has enabled him to devote the time and concentration his work has always demanded. The effect has been dramatic. Within two years the small, even discrete, portraits and still lives began to be developed in a much larger format. These works retained the immediacy of pen, pencil and watercolour but in their scale were brought closer to nature. The accomplishment of the massive *Rock and Sea Anglesey*, one of the most recent works in this exhibition, suggests that McComb's most impressive work has still to be made.

In bringing together this exhibition a number of people have helped. We should like to take this opportunity to thank the lenders who have generously allowed their works to travel; Richard Morphet who has continued his painstaking research of McComb's work into the essay for this catalogue; Paul Wakefield who specially photographed all of the works for reproduction; and not least to thank Barbara and Leonard McComb who together made the design for this catalogue in a manner which is wholly consistent with the care that has been devoted to the work in the exhibition.

David Elliott
Director, Museum of Modern Art, Oxford

Joanna Drew
Director of Art, Arts Council of Great Britain

I would like to thank the very many people who have helped to make this exhibition possible.
Leonard McComb.

ISBN 0 7287 0372 6
Exhibition organised by David Elliott and Carol Brown, Museum of Modern Art, Oxford, and Alister Warman,
Serpentine Gallery, London.
Catalogue and graphics by Barbara and Leonard McComb.
Photographs by Paul Wakefield, printed by Mike Campbell
Phototypeset in Perpetua 11 on 12-pt by Tradespools Limited, Frome, Somerset.
Printed on Parilux mat art paper 170gsm, cover and endpapers on Tre Kronor 225 & 120gsm, by Burgess & Son
(Abingdon) Ltd
© Copyright Arts Council of Great Britain 1983

A full list of Arts Council publications in print can be obtained from: The Publications Department, Arts Council of
Great Britain, 105 Piccadilly, London W1V 0AU